Draw 50
Famous Cartoons

BOOKS IN THIS SERIES

Draw 50 Famous Cartoons

LEE J. AMES

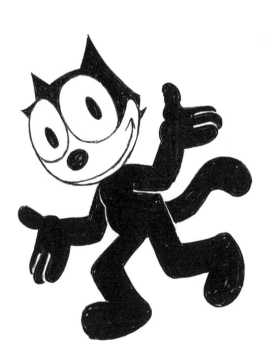

BROADWAY BOOKS
NEW YORK

BROADWAY

Published by Broadway Books
a division of Random House, Inc.
1540 Broadway, New York, New York 10036

BROADWAY BOOKS and it's logo, a letter B bisected on the diagonal, are
trademarks of Broadway Books, a division of Random House, Inc.

Library of Congress Cataloging-in-Publication Data
Ames, Lee J.
 Draw 50 famous cartoons.
 1. Cartooning—Technique. I. Title.
NC1320.A46 741'.5
ISBN 0-385-19521-4 (PBK)
Library of Congress Catalog Card Number 78-1176

To:

Murray Z.
Herb O.
Matt A.
Billy K.
Bob K.
Irv K.
Jerry L.
Si O.
Benjie R.
Ben S.
Phil S.
Jack S.
Harry S.
Bob S.
Joe W.
Marty W.
Marv Z.
Joe Z.
Harry R.
Si F.
Herb E.
Pepper I.
Jerry F.
Howie M.
Arthur Z.
Sam S.
Al F.
Muggy P.
Jesse G.
Cliff U.
and
Butch R.

…with much thanks to Holly Moylan for all her help.

To the Reader

This book will show you a way to draw many different cartoons. You need not start with the first. Choose whichever you wish. When you have decided, follow the step-by-step method shown. *Very lightly* and *carefully*, sketch out step number one. However, this step, which is the easiest, should be done *most carefully*. Step number two is added right to step number one, also lightly and also very carefully. Step number three is sketched right on top of numbers one and two. Continue this way to the last step. The last step, and the last step only, should be drawn in firmly.

It may seem strange to ask you to be extra careful when you are drawing what seem to be the easiest first steps, but this is most important because a careless mistake at the beginning may spoil the whole picture at the end. As you sketch out each step, watch the spaces between the lines, as well as the lines, and see that they are the same. After each step, you may want to lighten your work by pressing it with a kneaded eraser (available at art supply stores).

When you have finished, you may want to redo the final step in India ink with a fine brush or pen. When the ink is dry, use the kneaded eraser to clean off the pencil lines. The eraser will not affect the India ink.

Here are some suggestions: In the first steps, even

when all seems quite correct, you might do well to hold your work up to a mirror. Sometimes the mirror shows that you've twisted the drawing off to one side without being aware of it. At first you may find it difficult to draw the different shapes, or just to make the pencil go where you want it to. Don't be discouraged. The more you practice, the more you will develop control. The only equipment you'll need will be a medium or soft pencil, paper, the kneaded eraser and, if you wish, pen or brush and India ink—or a felt-tipped pen—for the final step.

The first steps in this book are shown darker than necessary so that they can be clearly seen. (Keep your work very light.)

Remember, there are many other ways and methods to draw cartoons. This book shows just one method. Why don't you seek out other ways—from teachers, from libraries and, most importantly...from inside yourself?

LEE J. AMES

To the Parent or Teacher

"David can draw Popeye better than any of the other kids!" Such peer acclaim and encouragement generate incentive. Contemporary methods of art instruction (freedom of expression, experimentation, self-evaluation of competence and growth) provide a vigorous, fresh-air approach for which we must all be grateful.

New ideas need not, however, totally exclude the old. One such is the "follow me, step-by-step" approach. In my young learning days this method was so common, and frequently so exclusive, that the student became nothing more than a pantographic extension of the teacher. In those days it was excessively overworked.

This does not mean, however, that the young hand is never to be guided. Rather, specific guiding is fundamental. Step-by-step guiding that produces satisfactory results is valuable even when the means of accomplishment are not fully understood by the student.

The novice with a musical instrument is frequently taught to play simple melodies as quickly as possible, well before he learns the most elemental scratchings at the surface of music theory. The resultant self-satisfaction, pride in accomplishment, can be a significant means of providing motivation. And all from mimicking an instructor's "Do as I do."

Mimicry is a prerequisite for developing creativity.

We learn the use of our tools by mimicry. Then we can use those tools for creativity. To this end I would offer the budding artist the opportunity to memorize or mimic (rote-like, if you wish) the making of cartoons—cartoons he has been anxious to be able to draw.

The use of this book should be available to anyone who *wants* to try another way of drawing. Perhaps, with his friends' encouragement, "David can draw Popeye better...," he will be persuaded to continue, to experiment, and finally to create his own cartoon style.

LEE J. AMES

Draw 50
Famous Cartoons

POPEYE

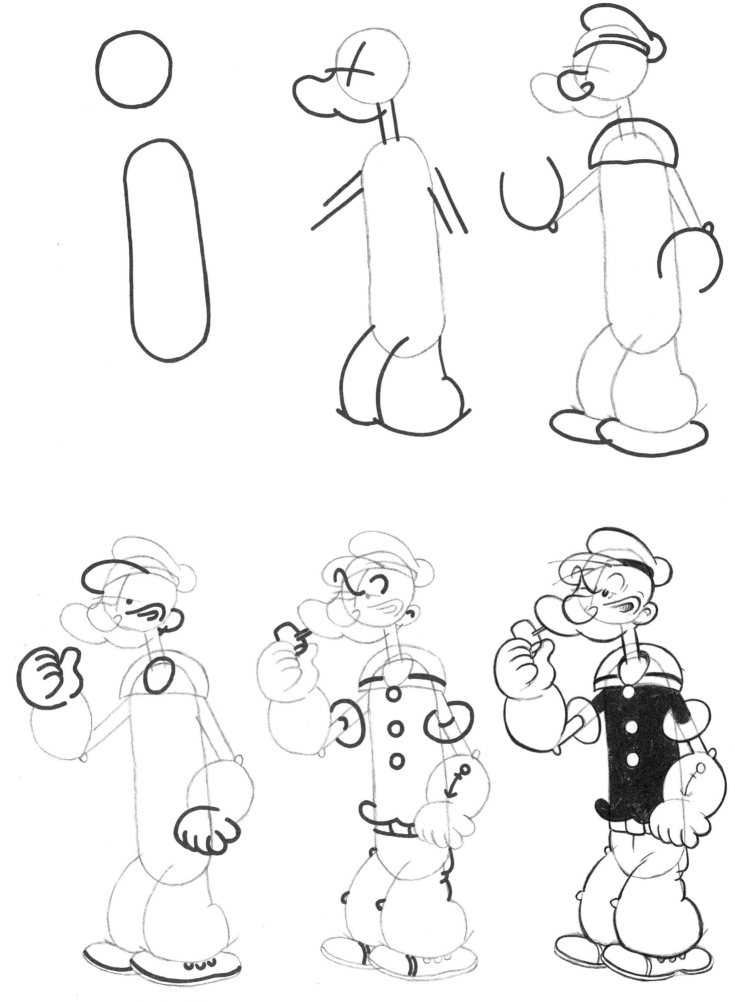

BLONDIE

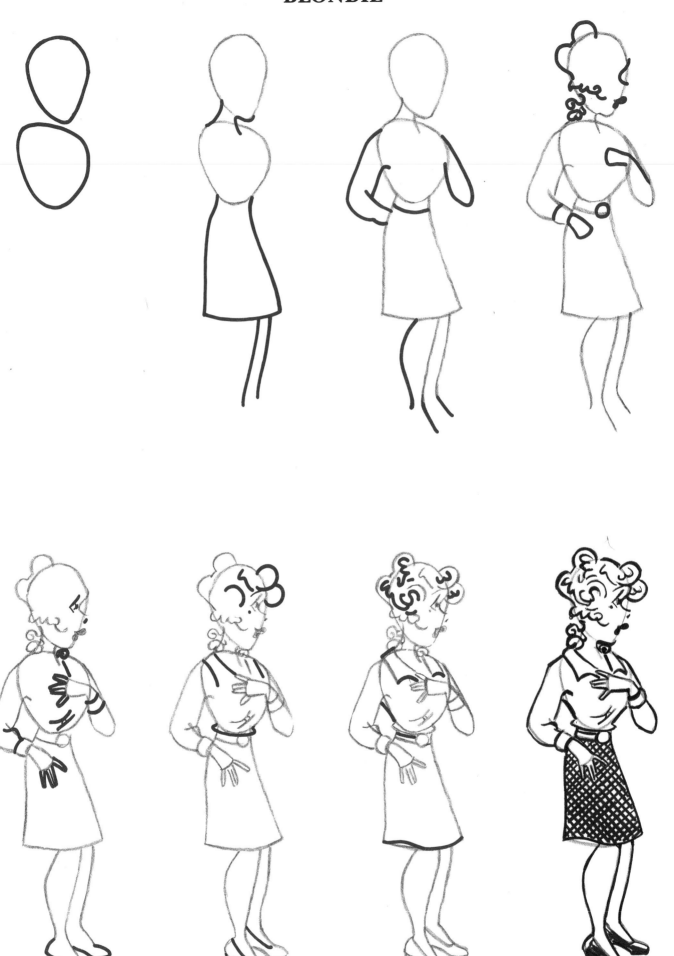

DAGWOOD

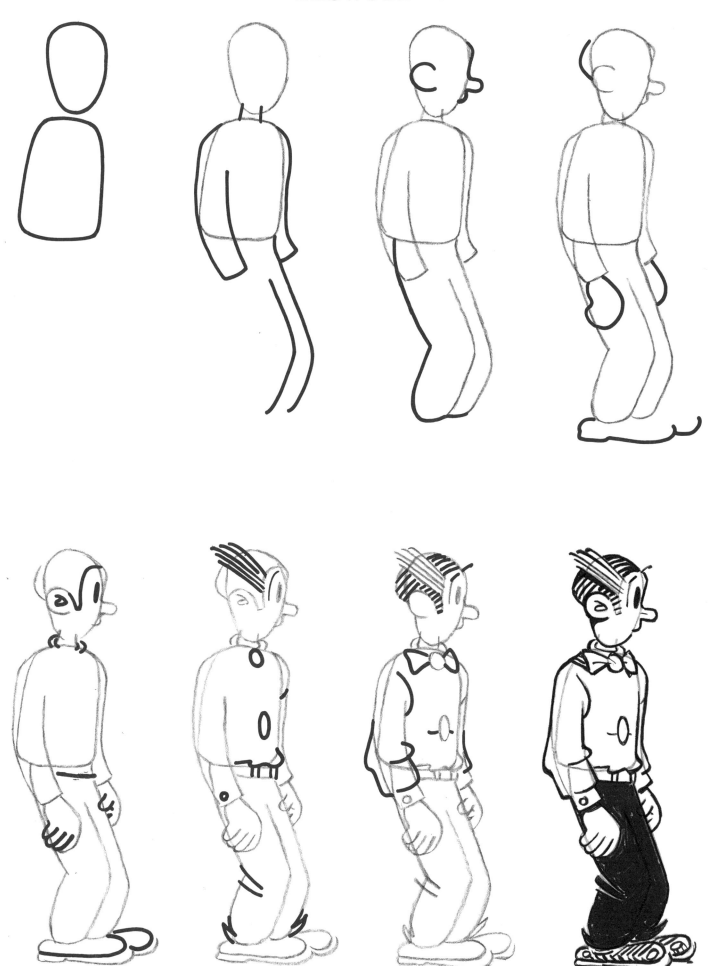

ARCHIE

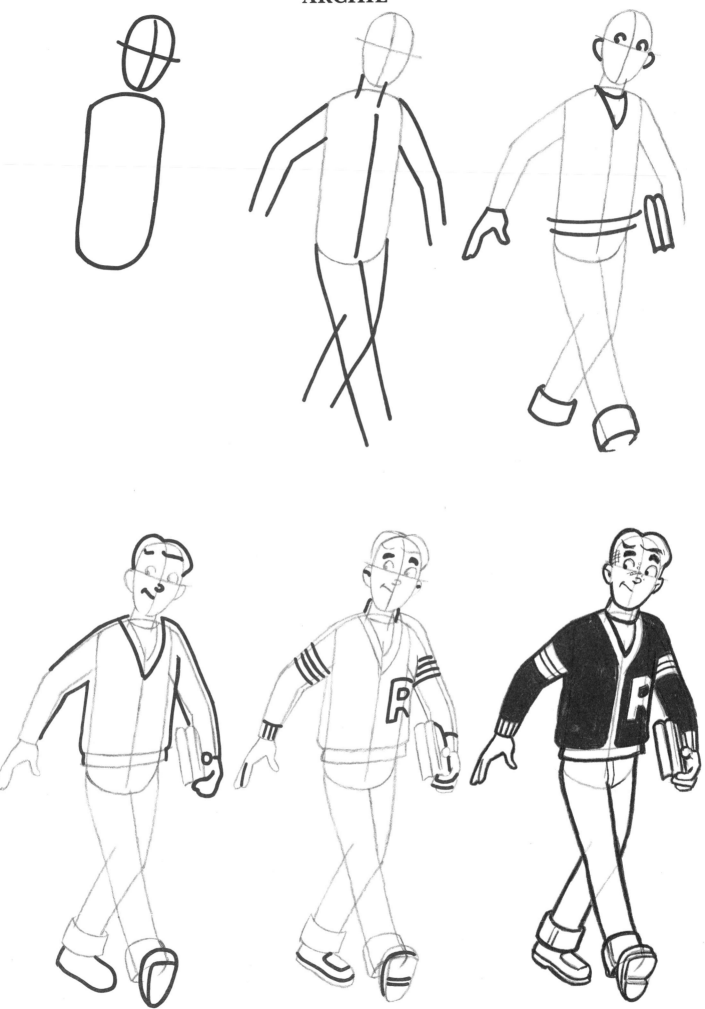

VERONICA

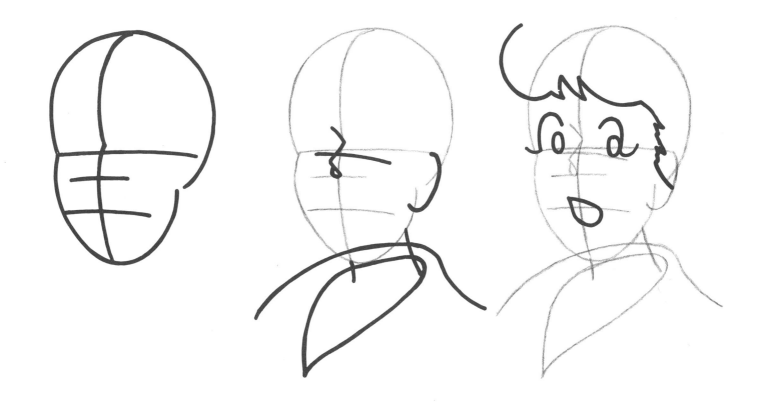

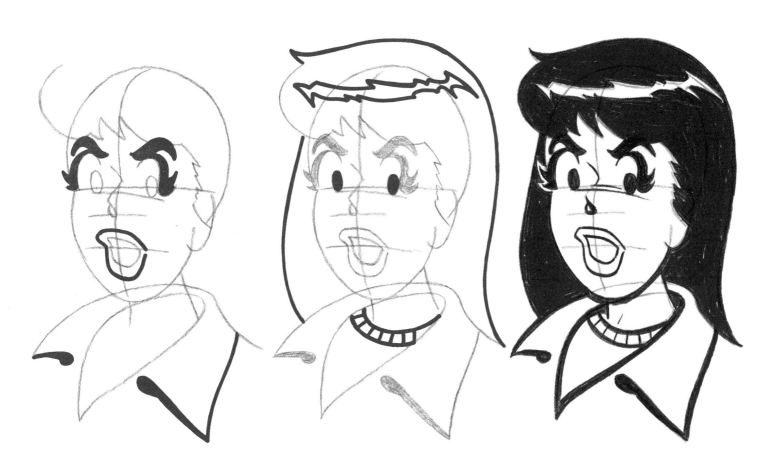

JUGHEAD

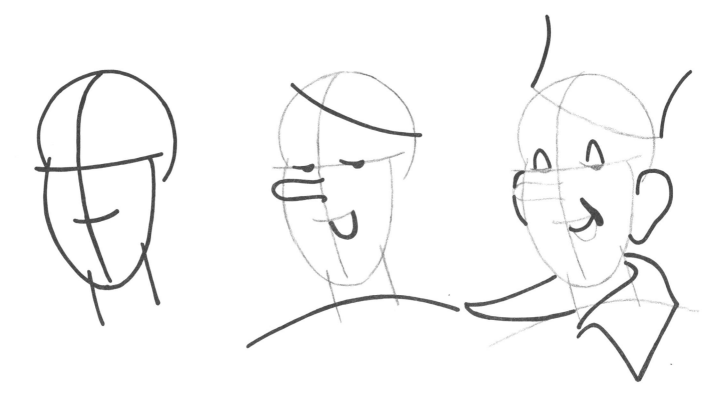

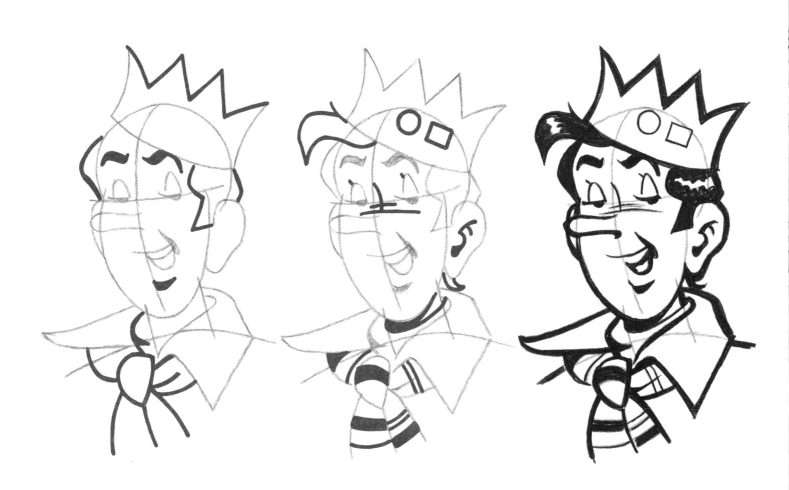

TINTIN

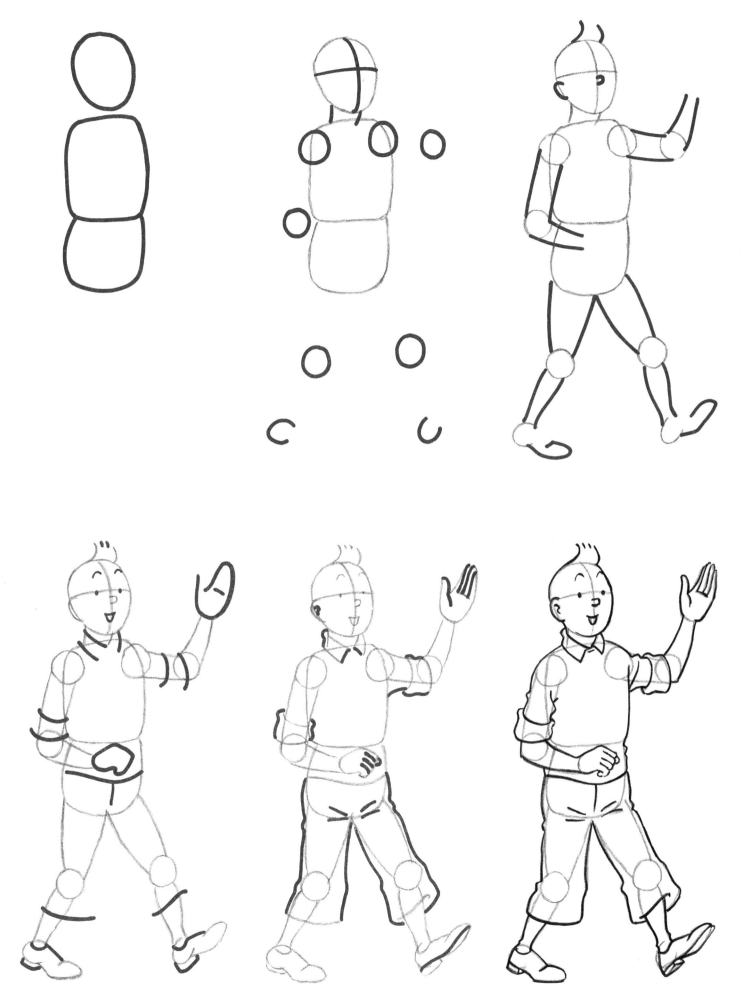

HI and LOIS

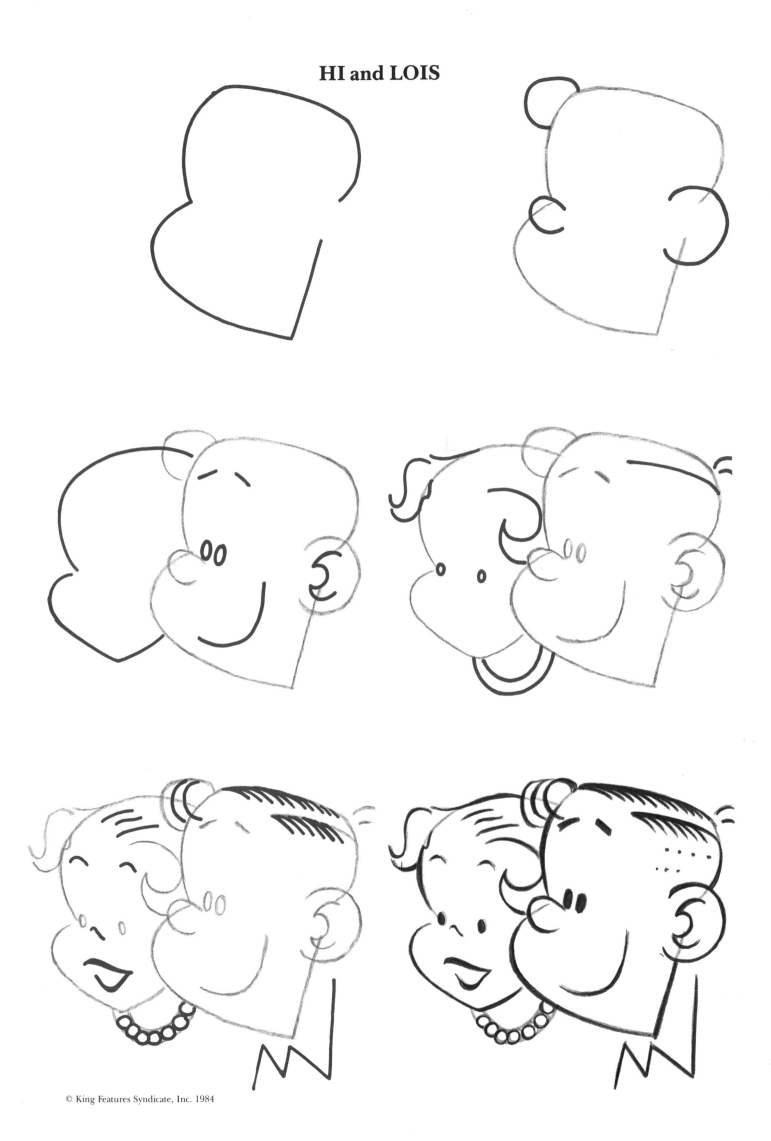

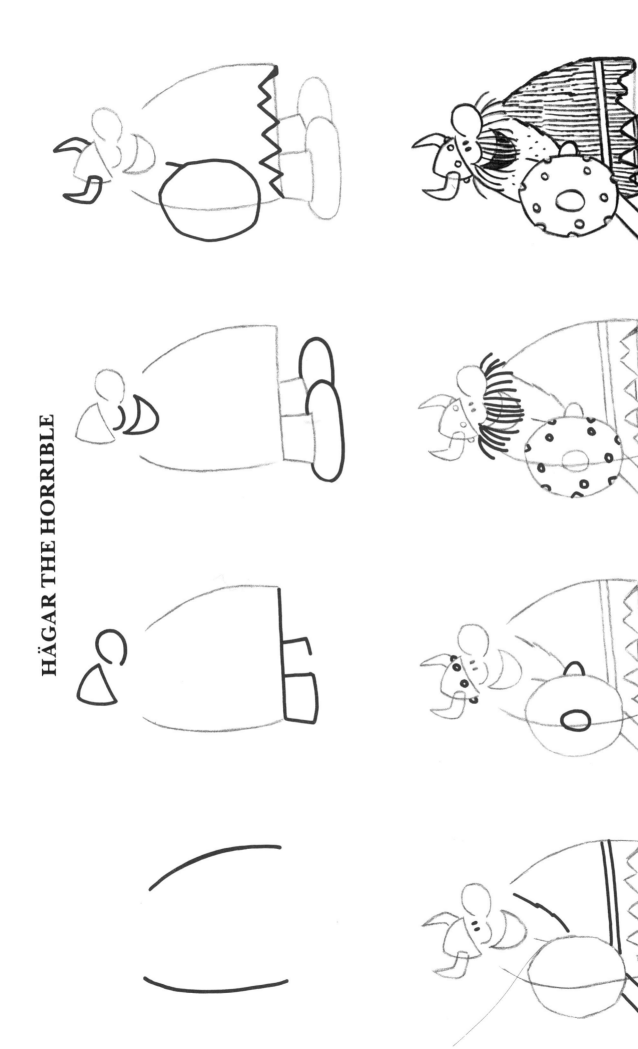

THE LITTLE KING

THE KATZENJAMMER KIDS

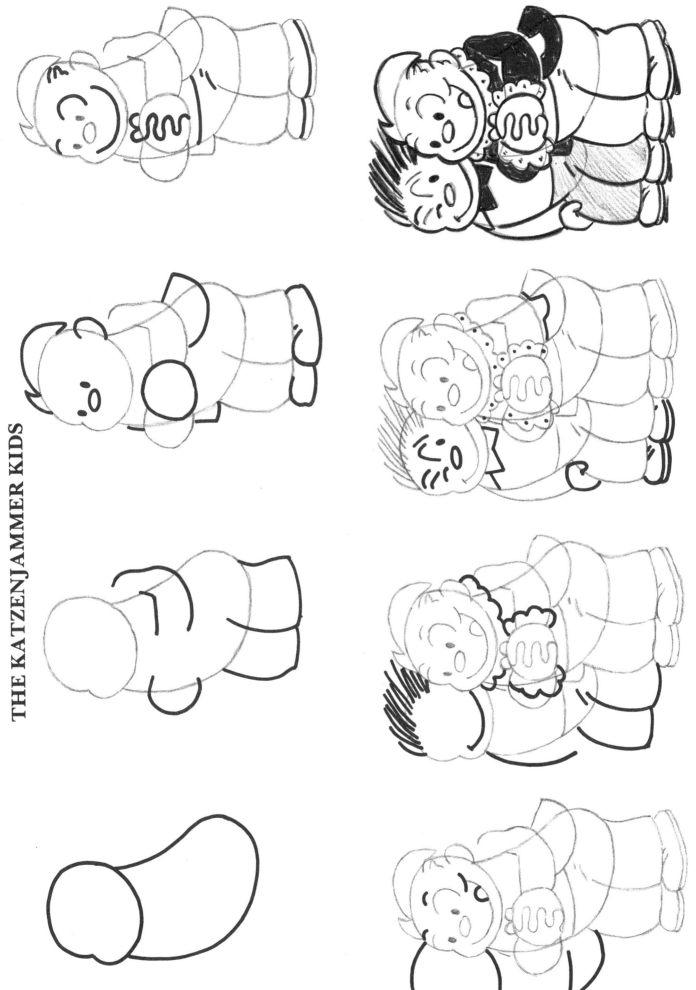

ALFRED E. NEUMAN

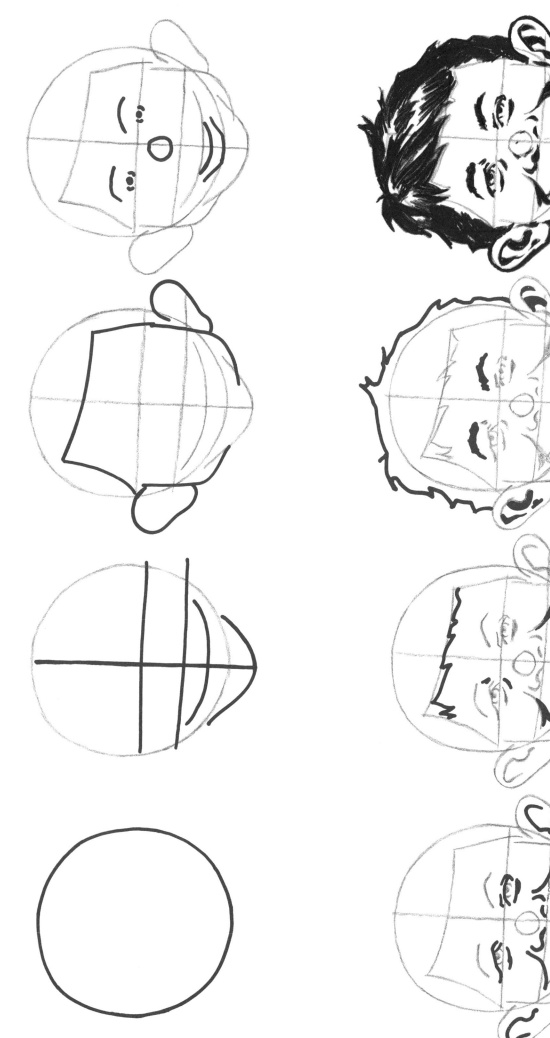

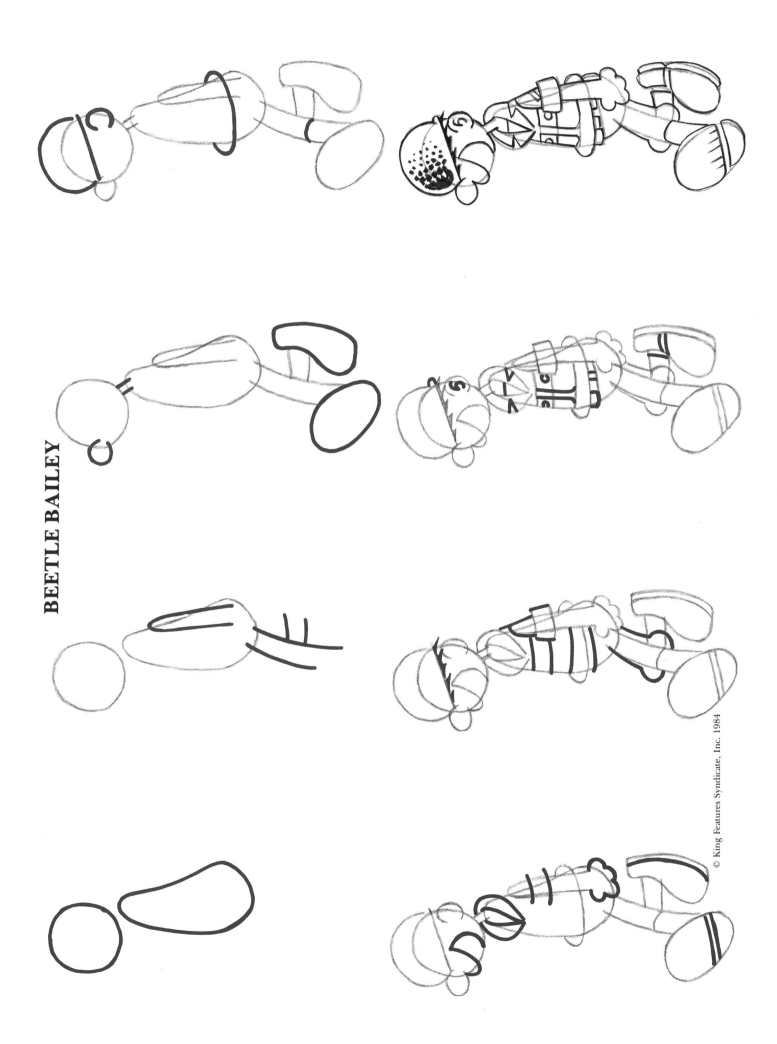

BEETLE BAILEY

FRED FLINTSTONE

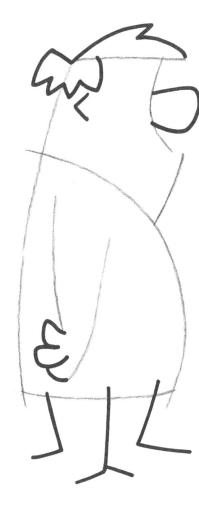
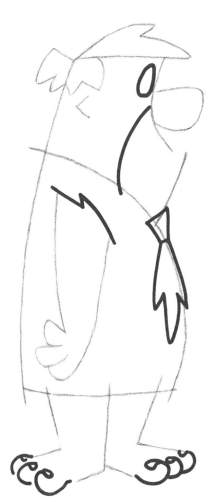
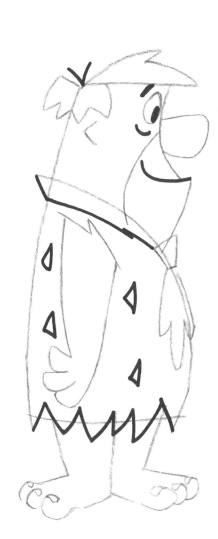
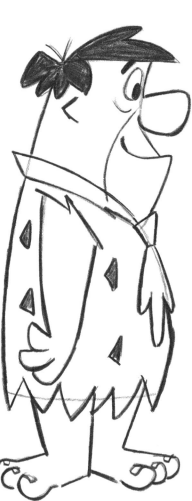

WILMA FLINTSTONE

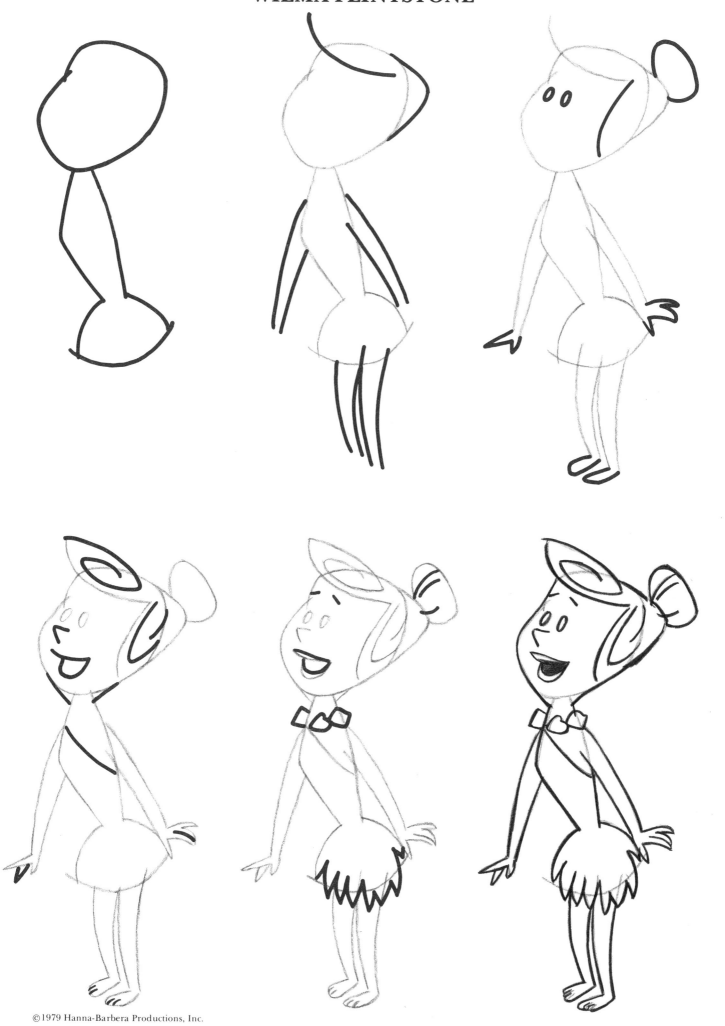

BARNEY RUBBLE

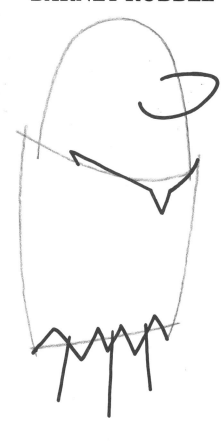
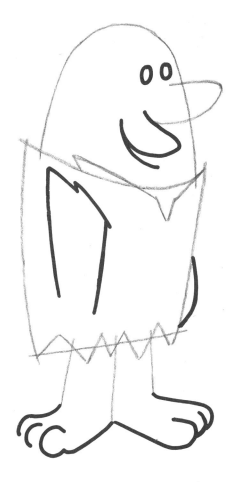
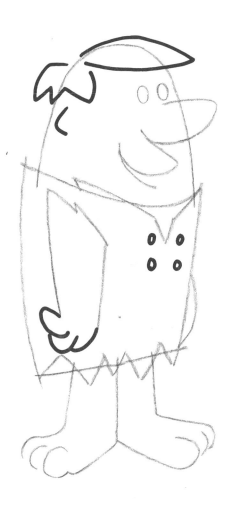
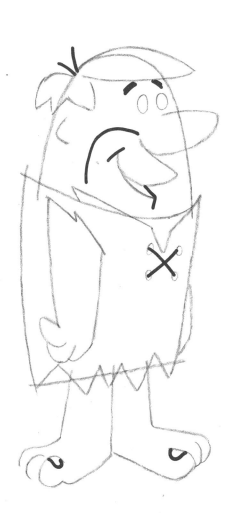
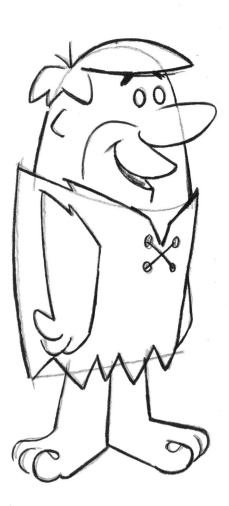

DINO

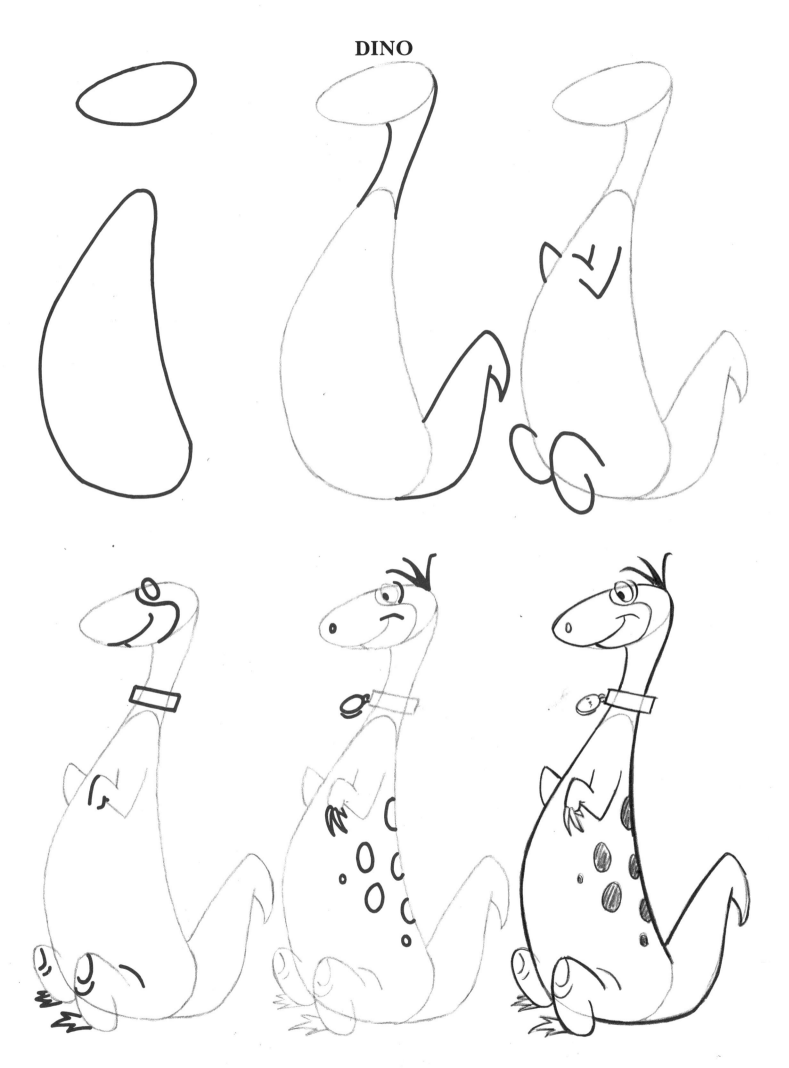

DICK TRACY

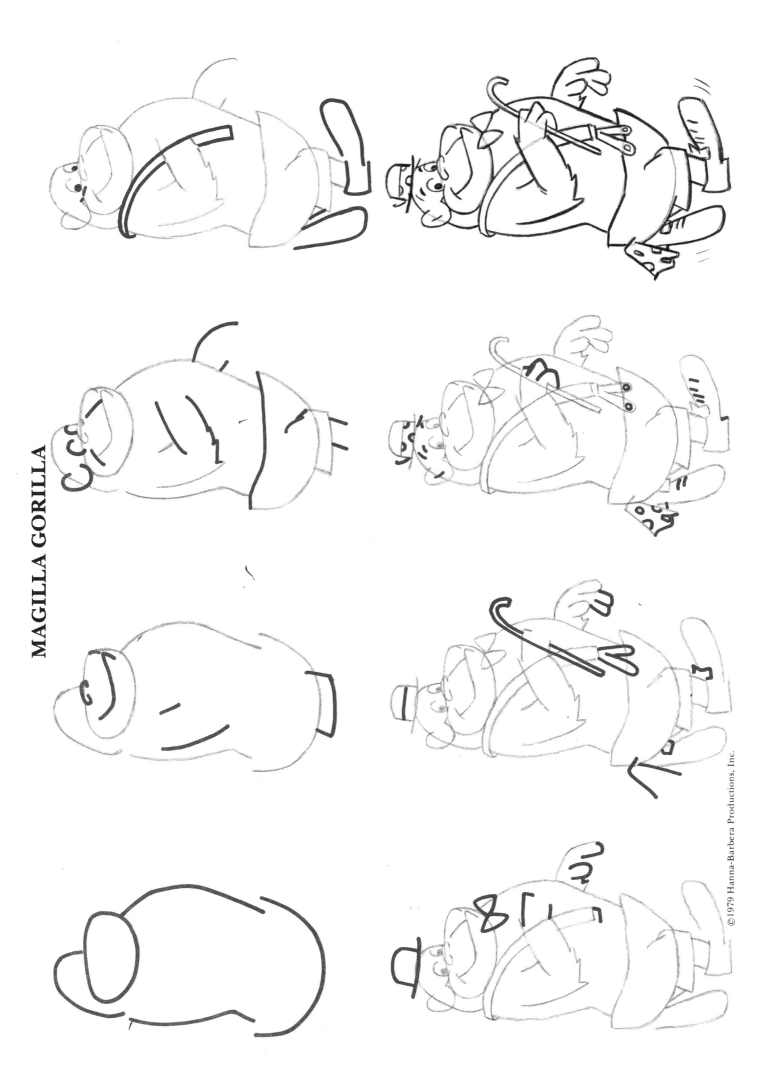

MAGILLA GORILLA

YOGI BEAR

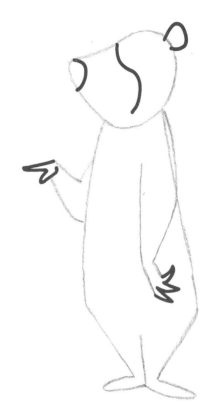
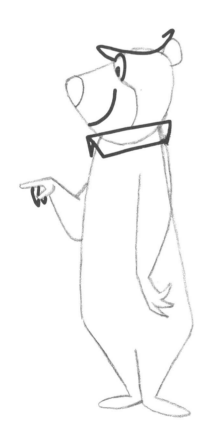
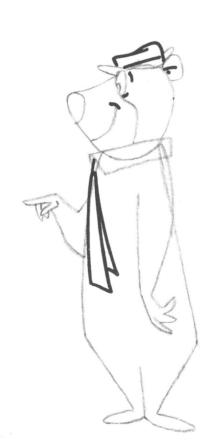
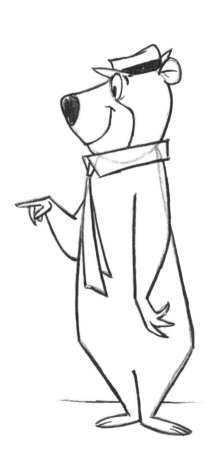

Baby

BOO BOO

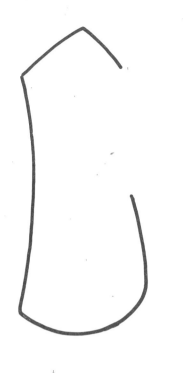
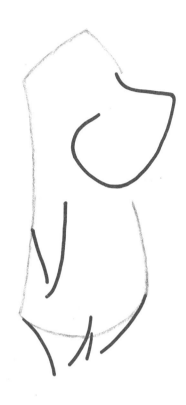
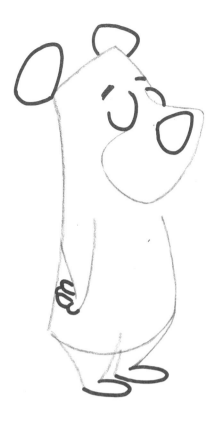

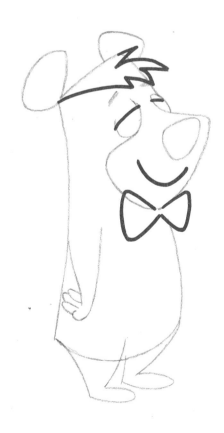
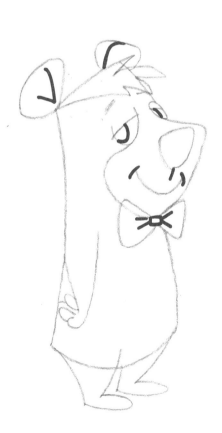
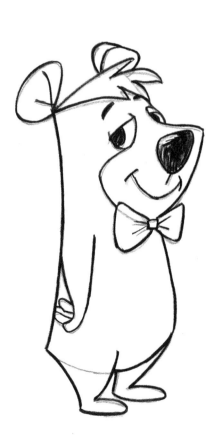

THE PHANTOM

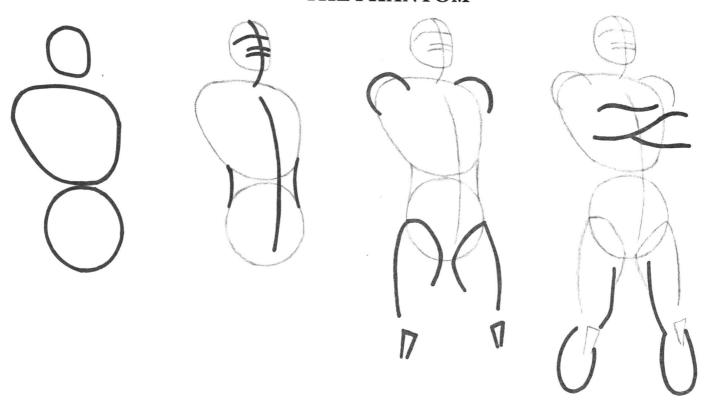

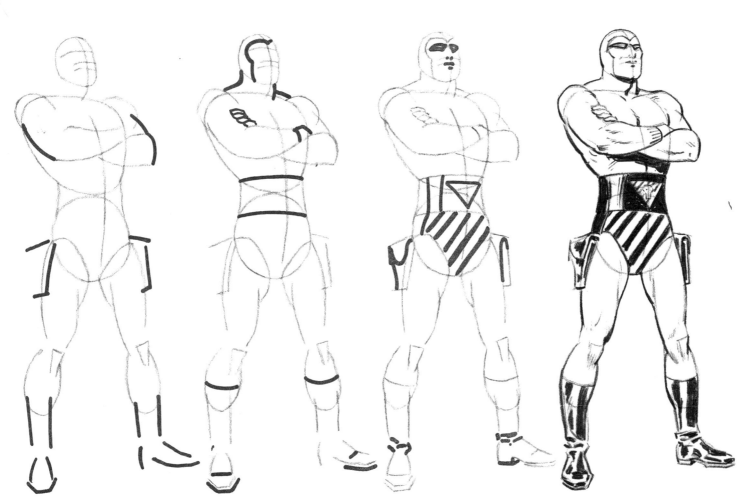

FELIX THE CAT

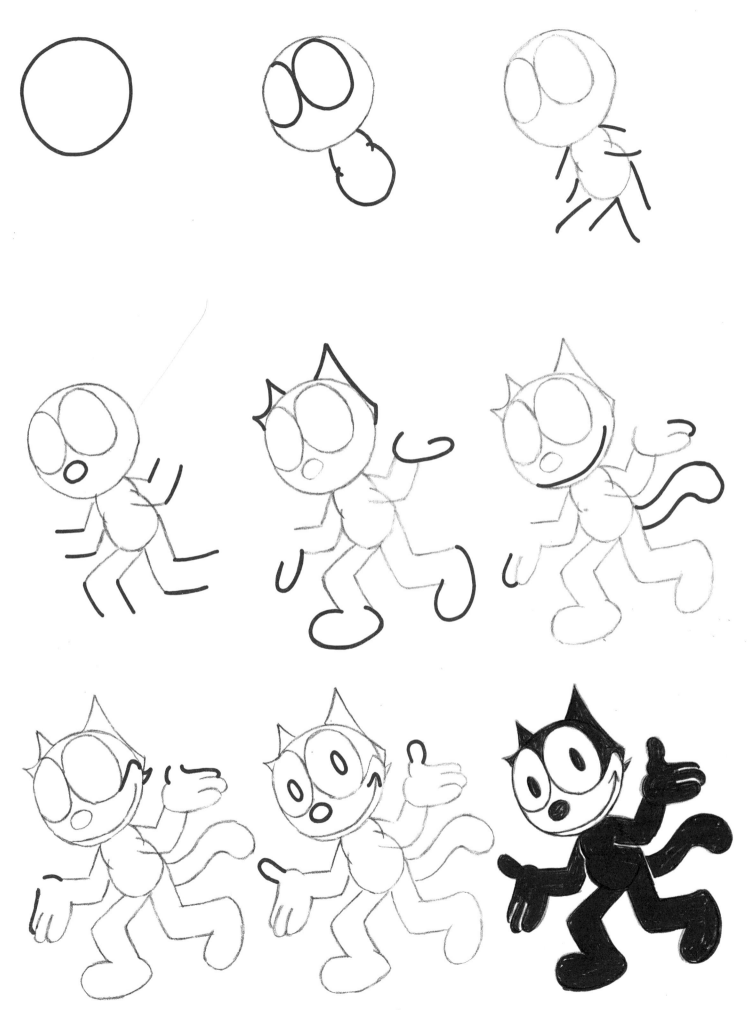

LITTLE ORPHAN ANNIE

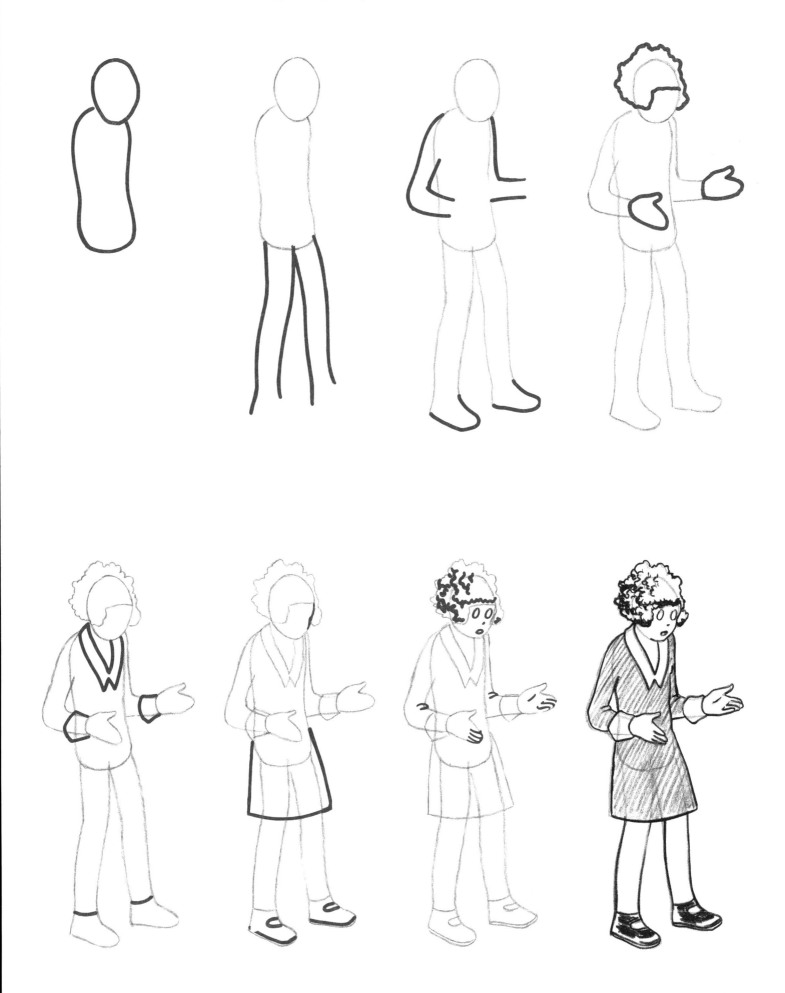

SANDY

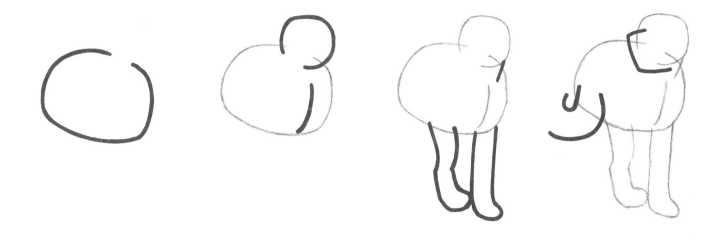

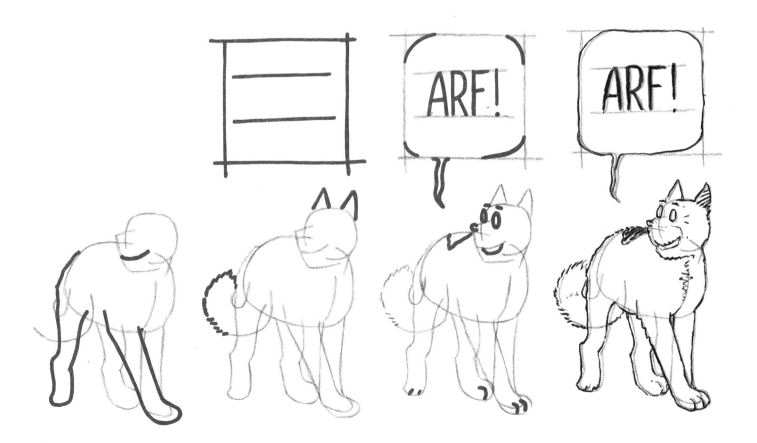

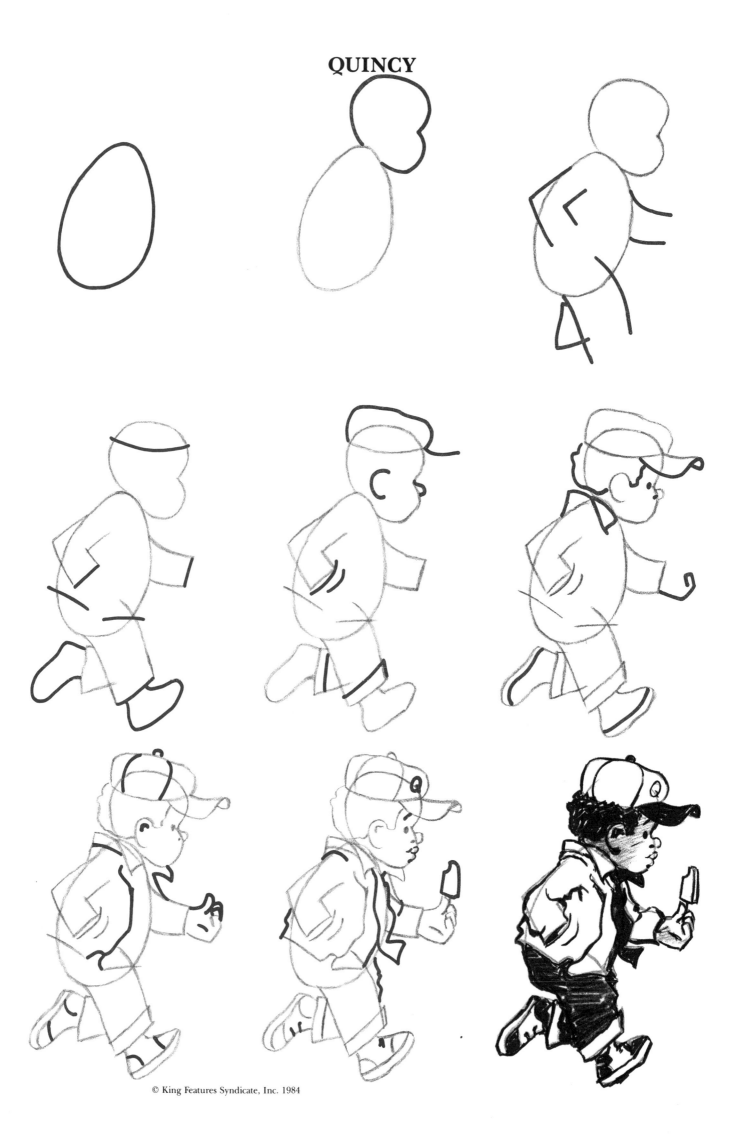

QUINCY

© King Features Syndicate, Inc. 1984

KRAZY KAT and IGNATZ MOUSE

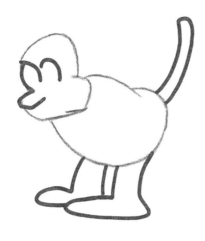
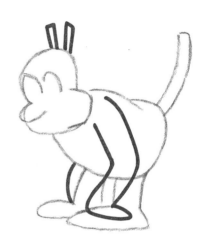
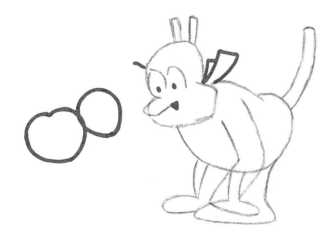
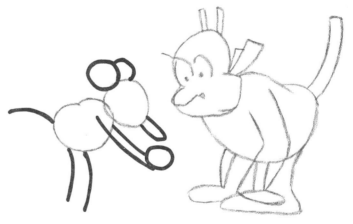
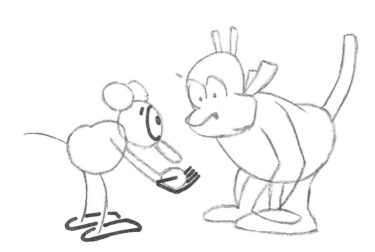
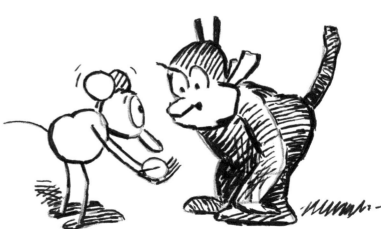

SNUFFY SMITH

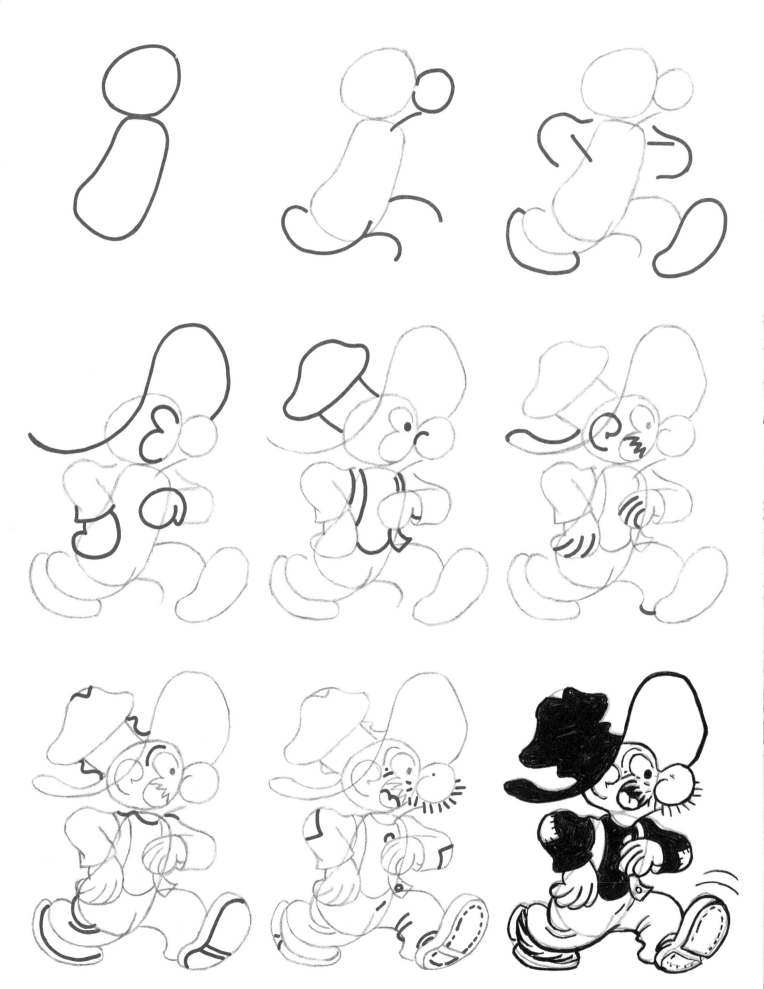

JIGGS

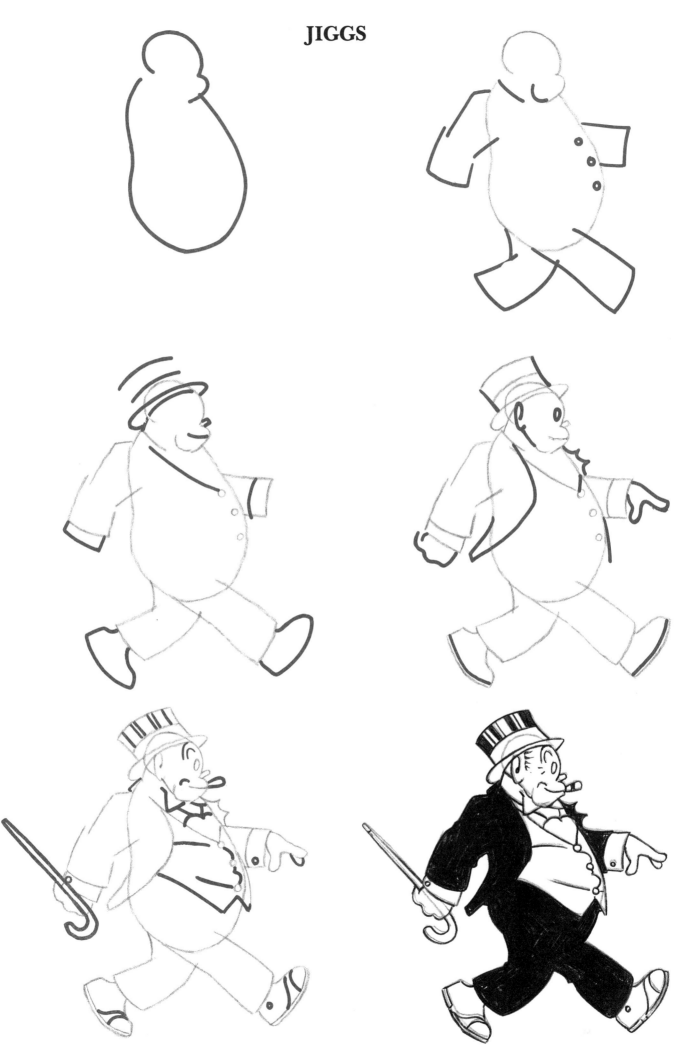

FLASH GORDON

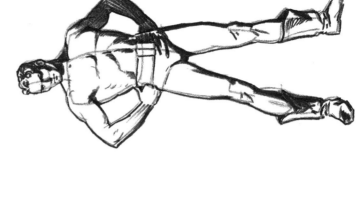

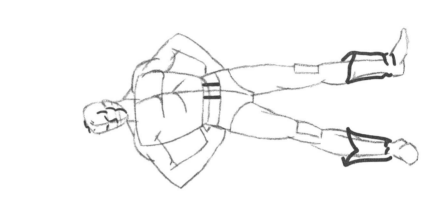

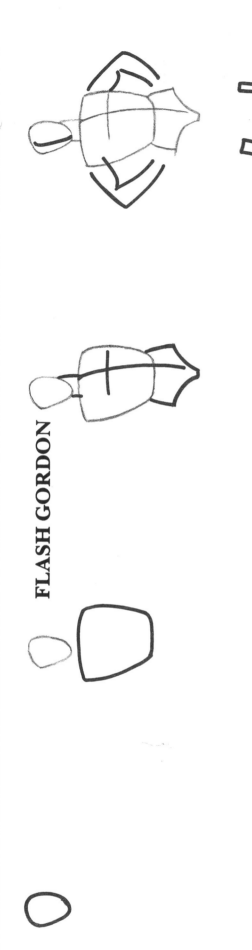

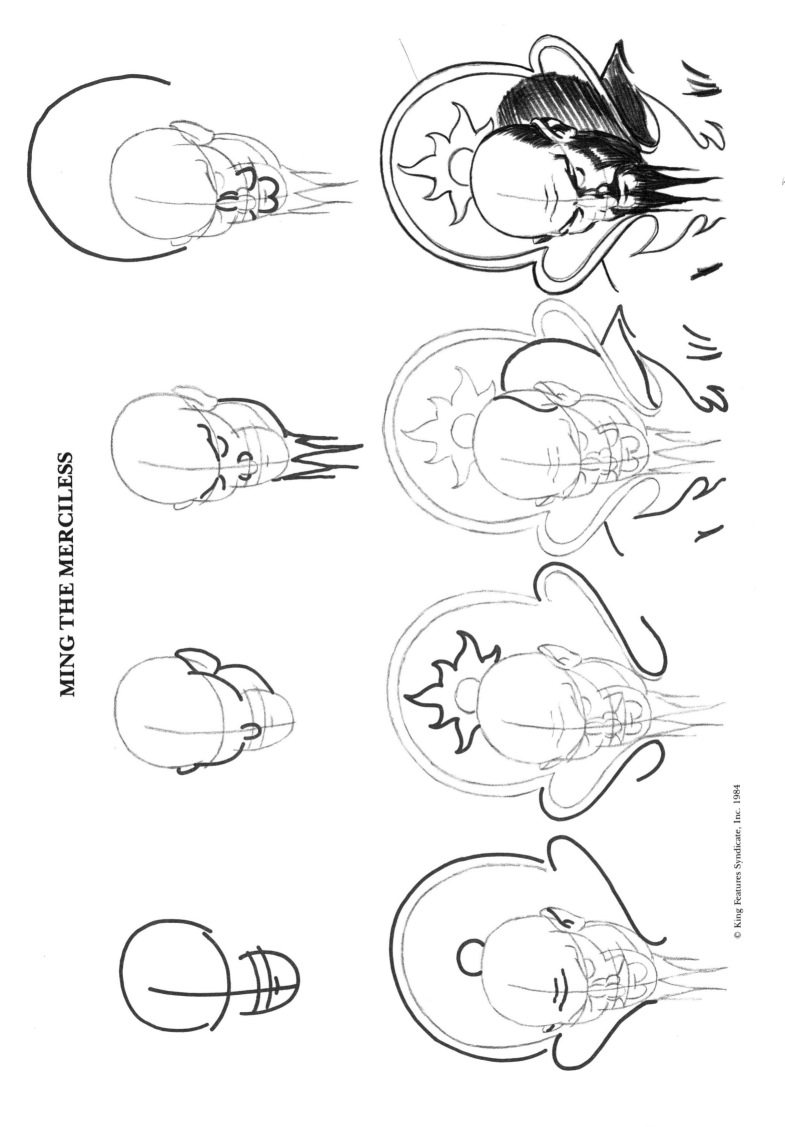

MING THE MERCILESS

BROOM-HILDA

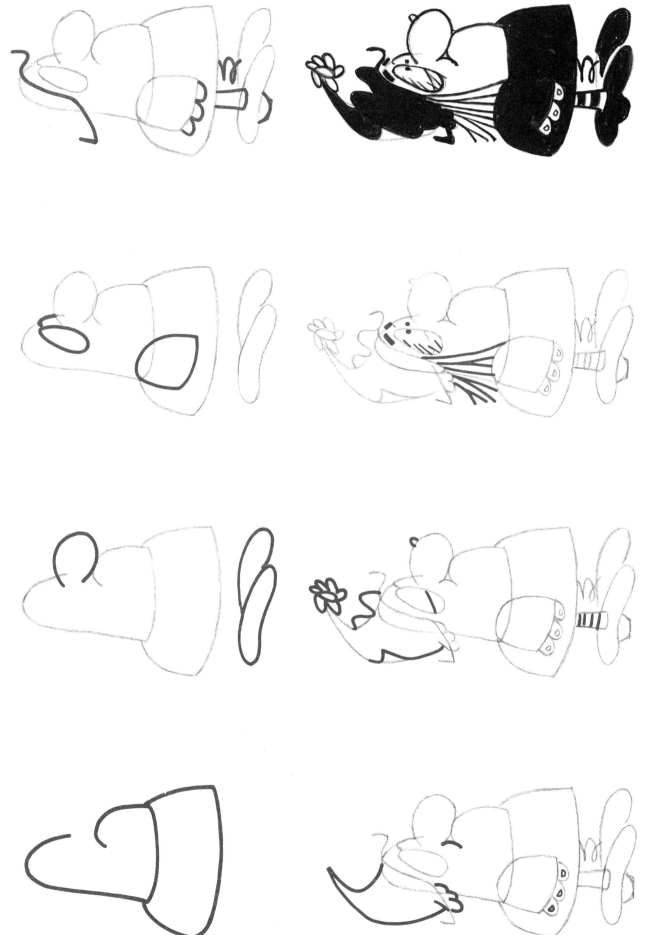

CATFISH

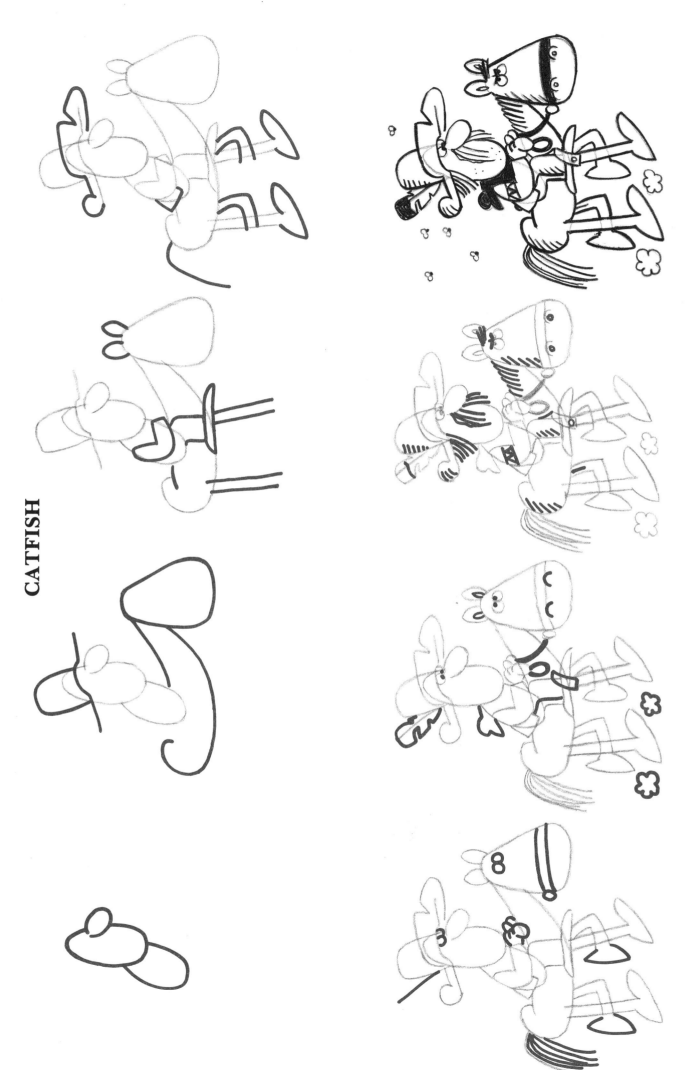

HUCKLEBERRY HOUND

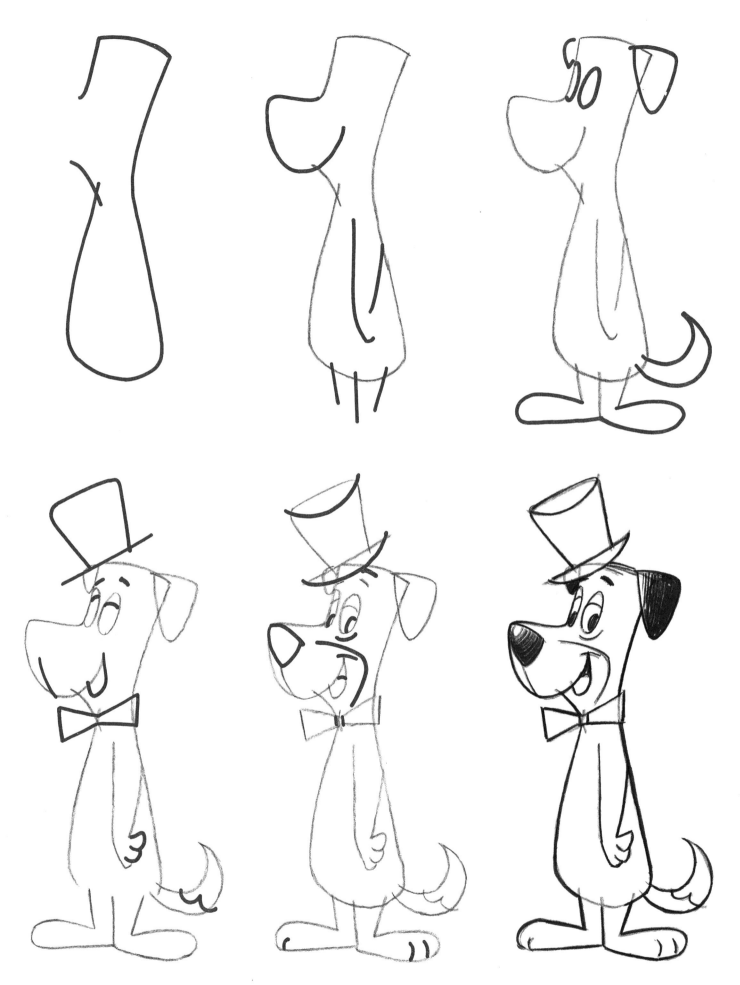

SNAGGLEPUSS

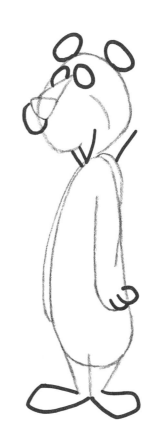

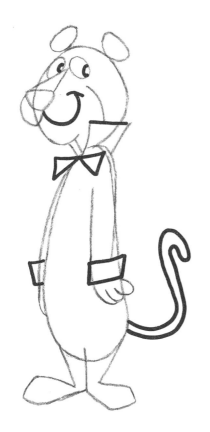
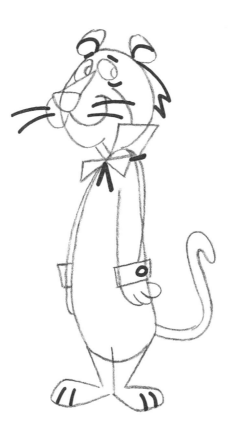
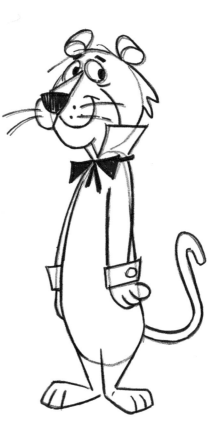

MUTT and JEFF

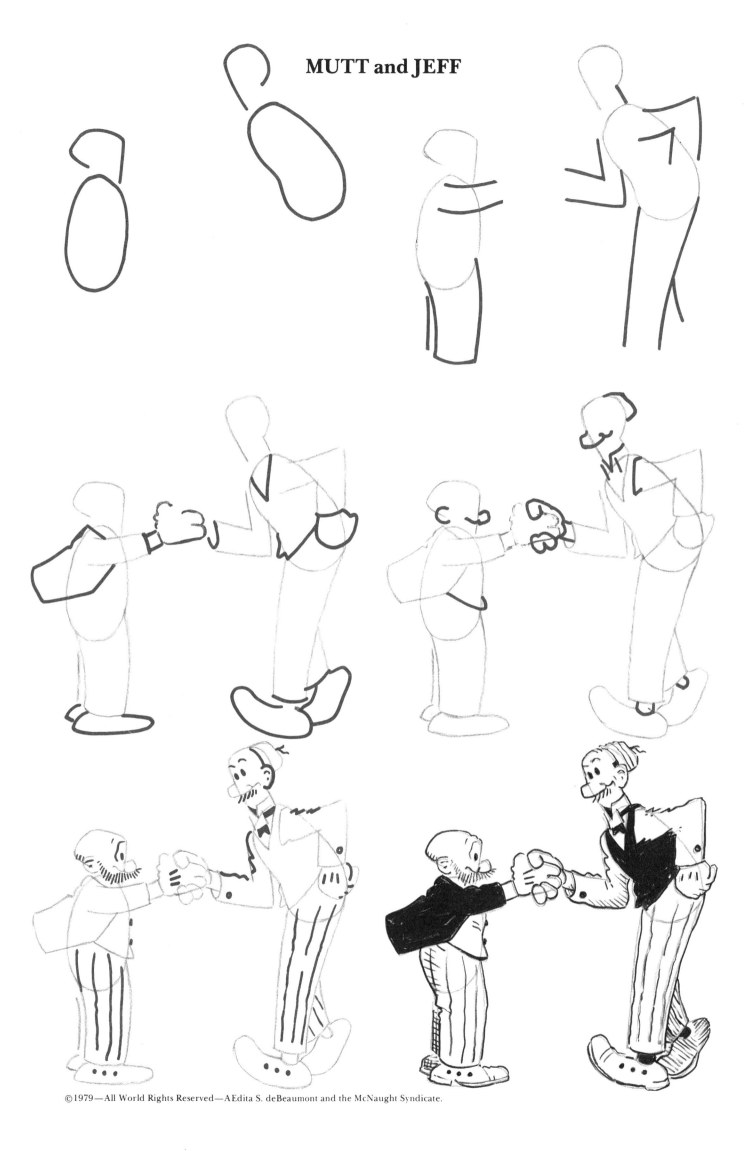

MR. LOCKHORN

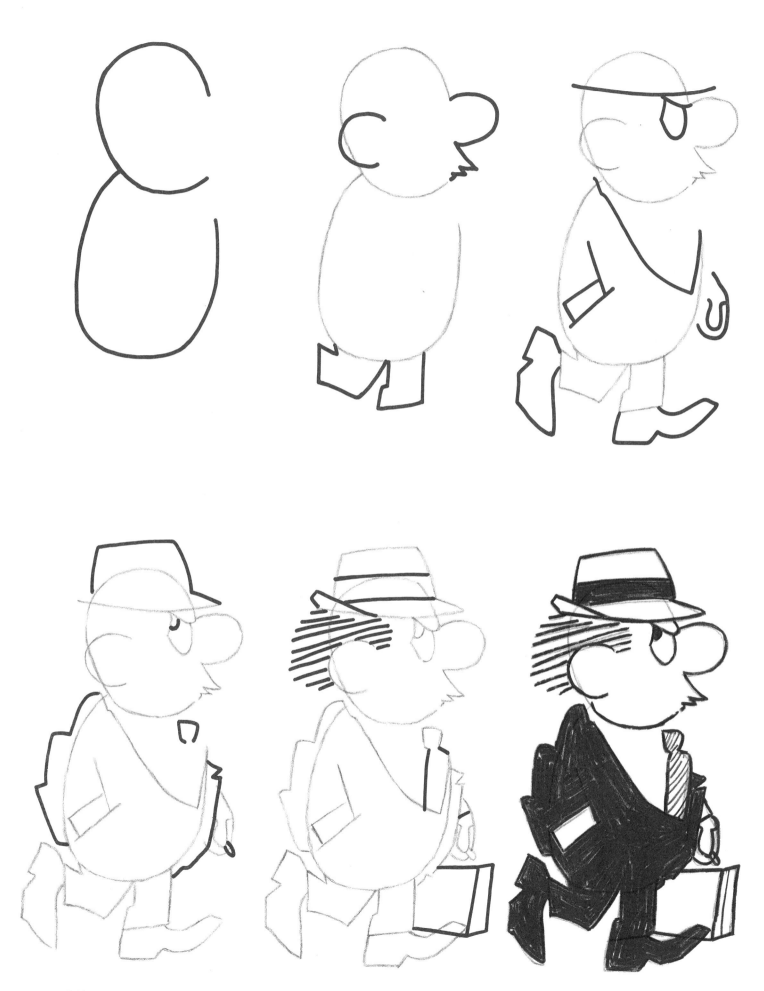

MRS. LOCKHORN

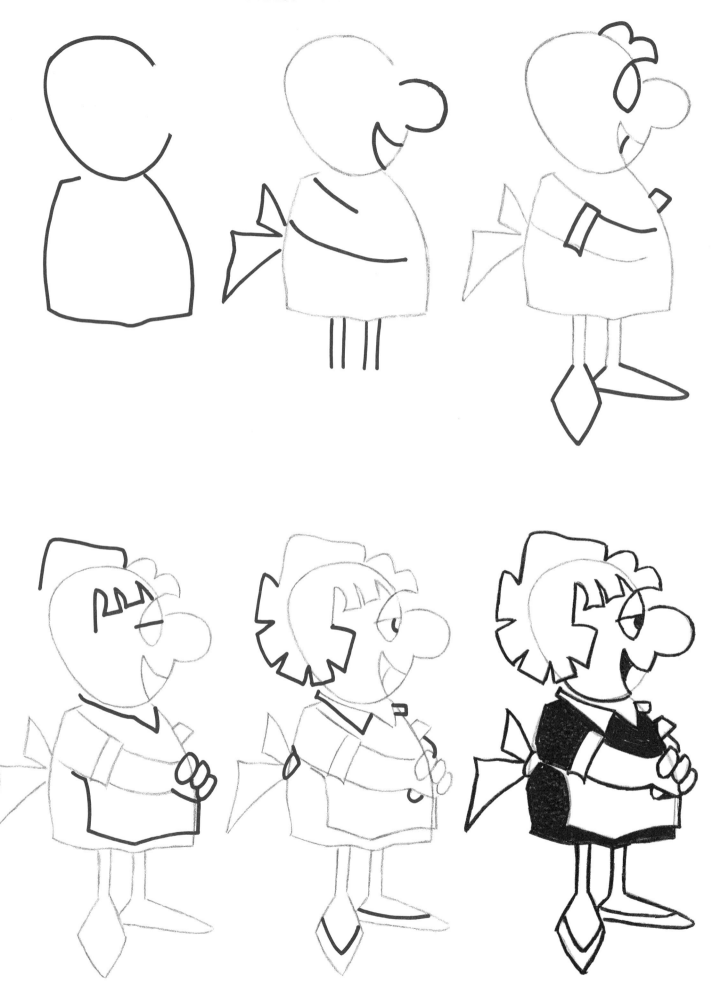

AGATHA CRUMM

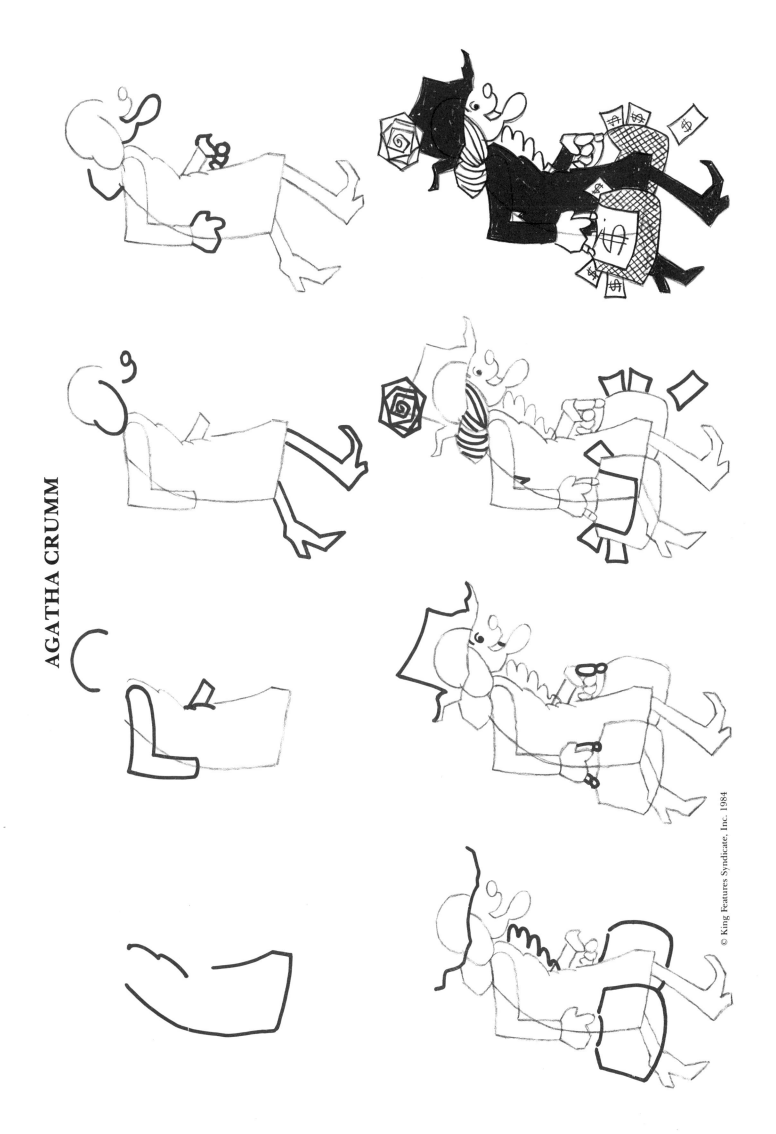

BROTHER JUNIPER

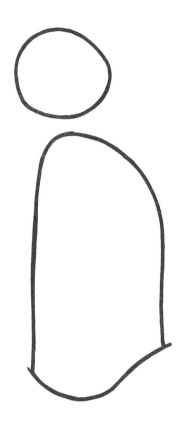 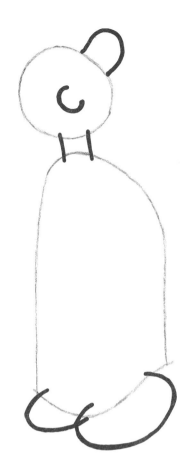 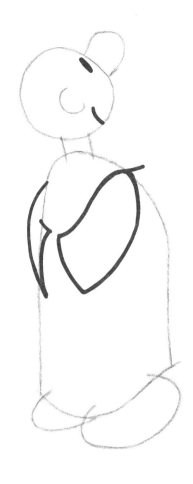

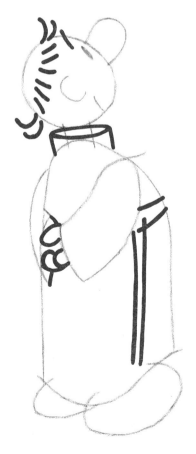 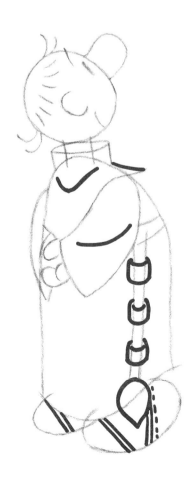 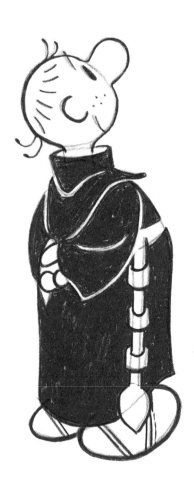

ANDY CAPP

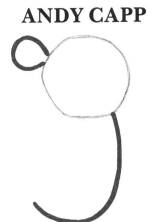
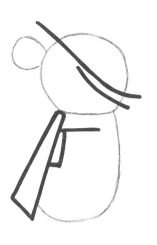

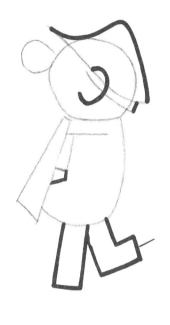
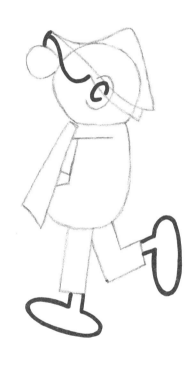
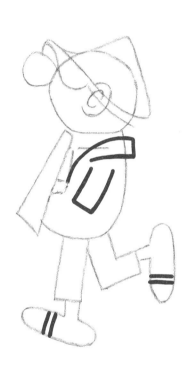

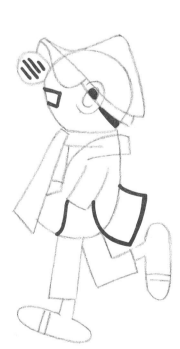
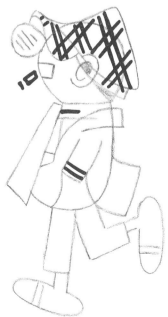
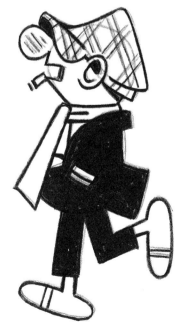

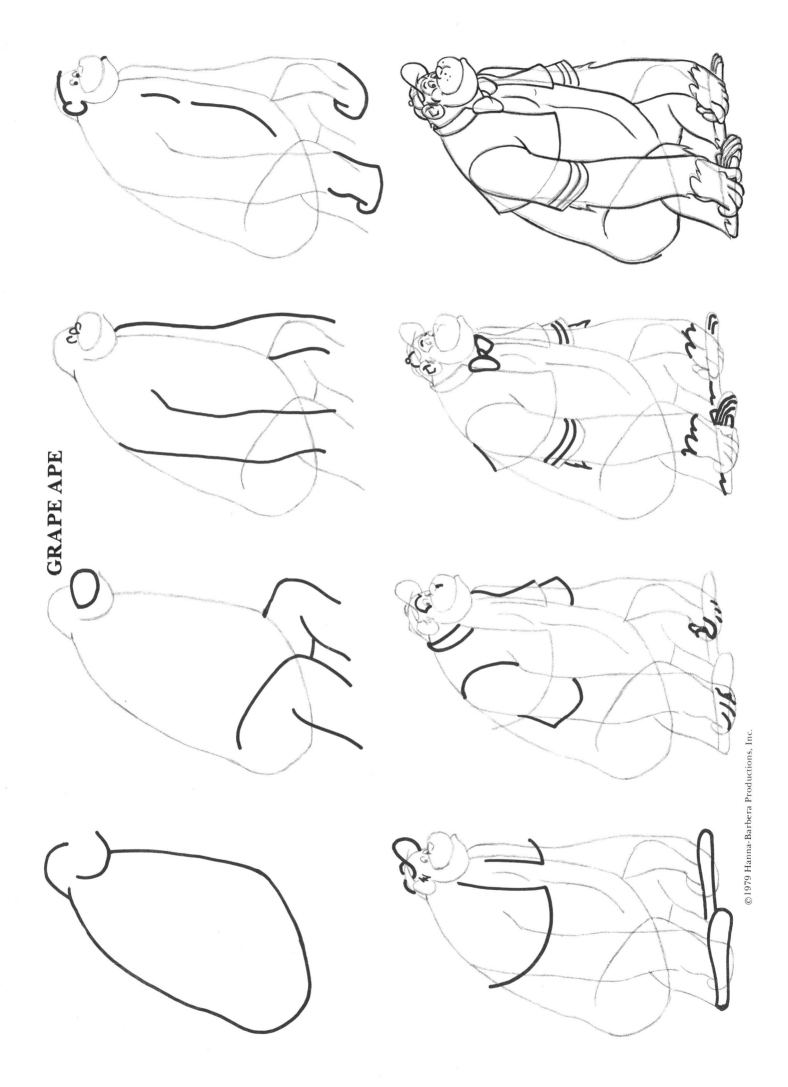

GRAPE APE

HOKEY WOLF

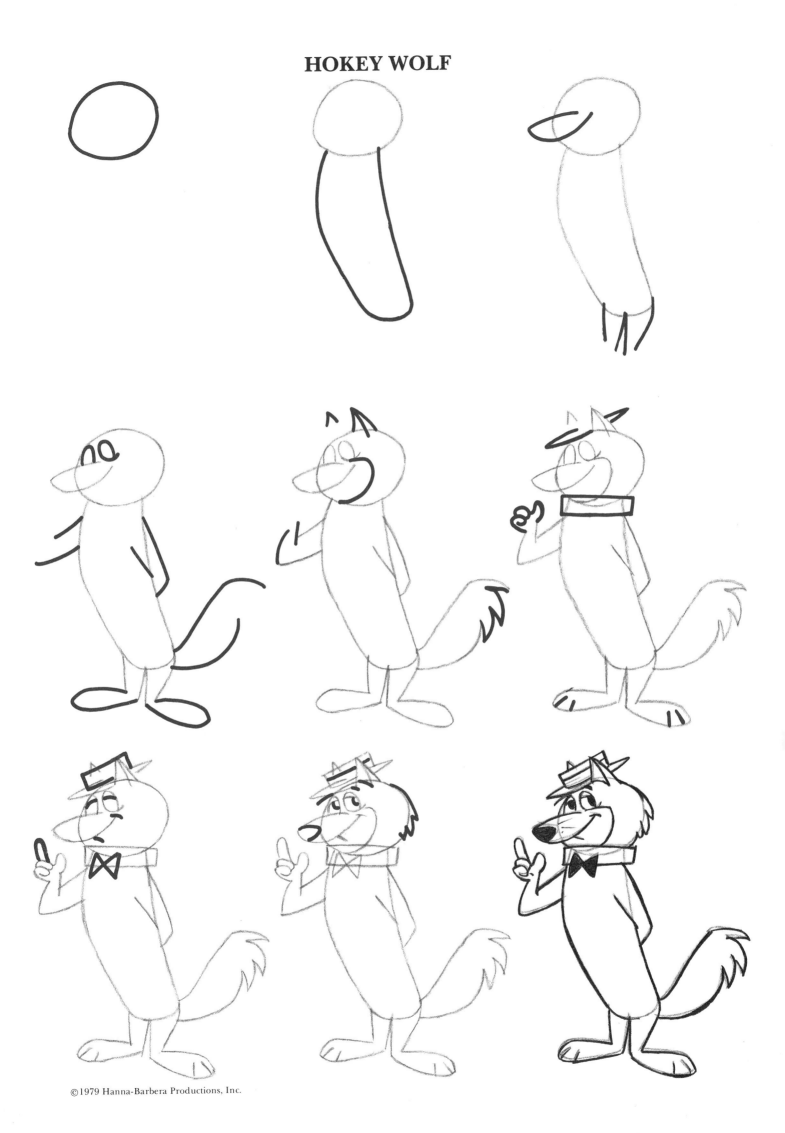

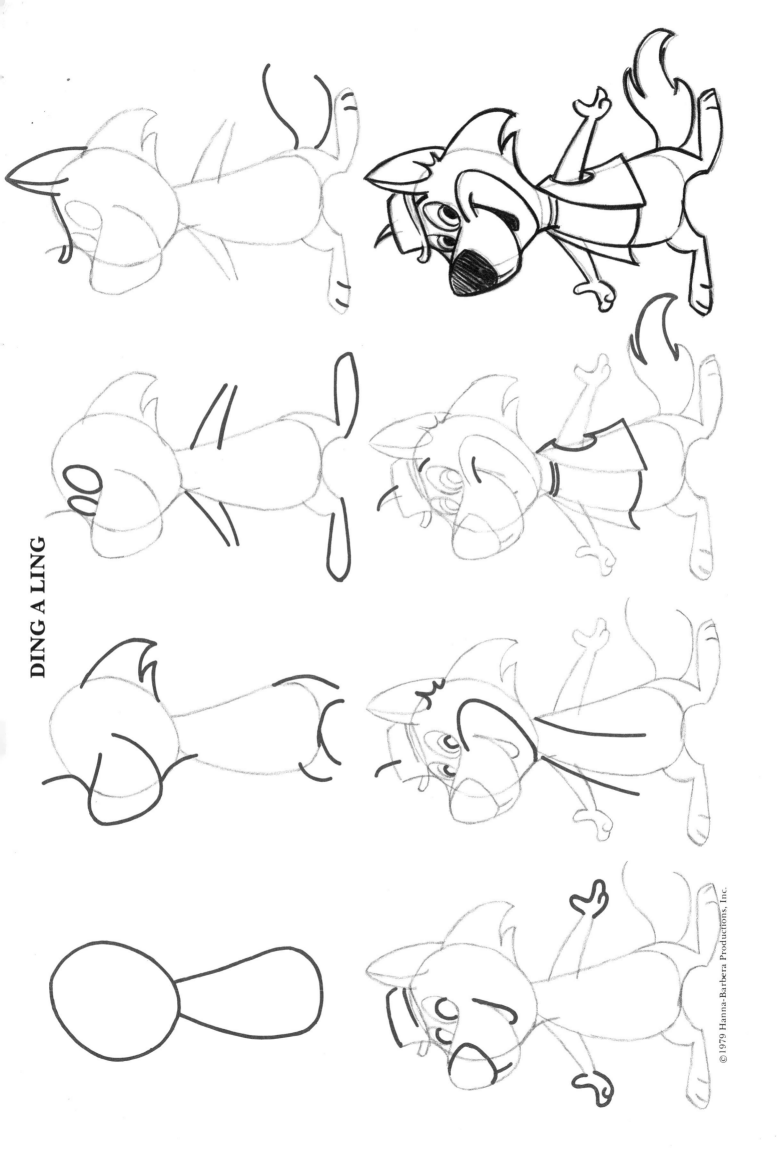

DING A LING

BABY PUSS

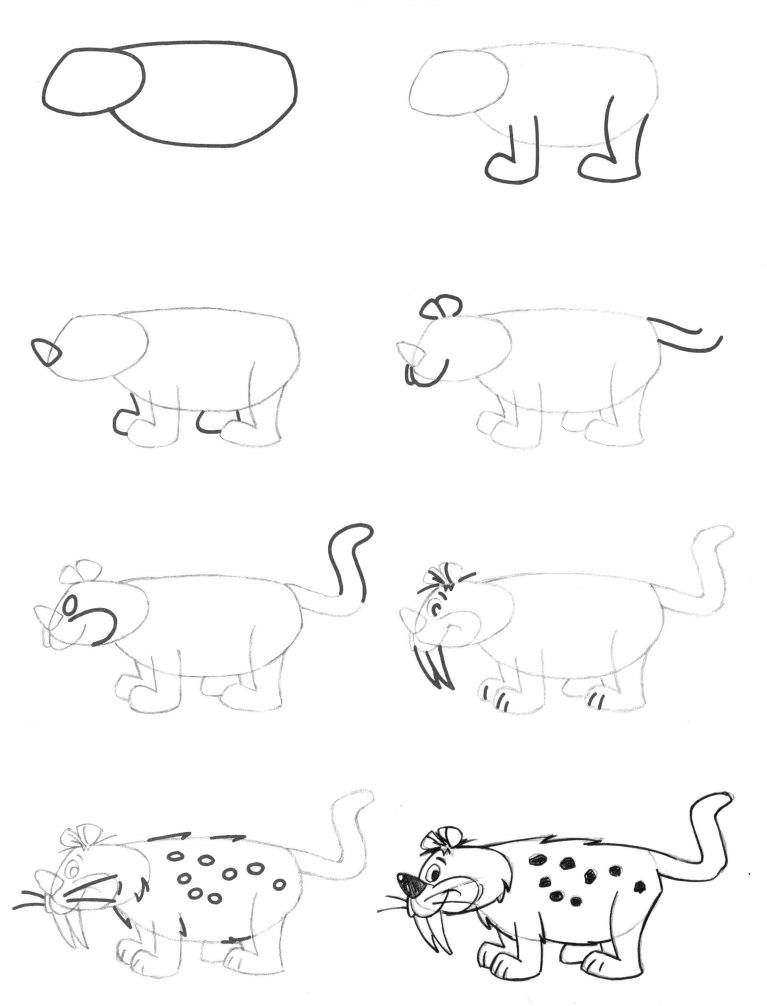

SCOOBY DOO

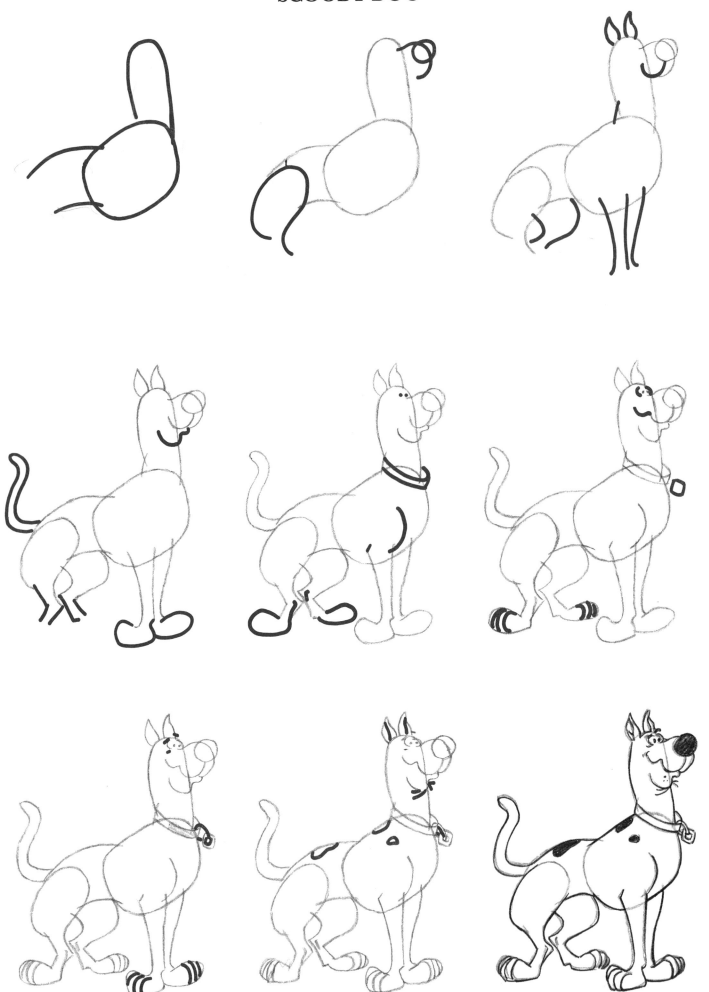

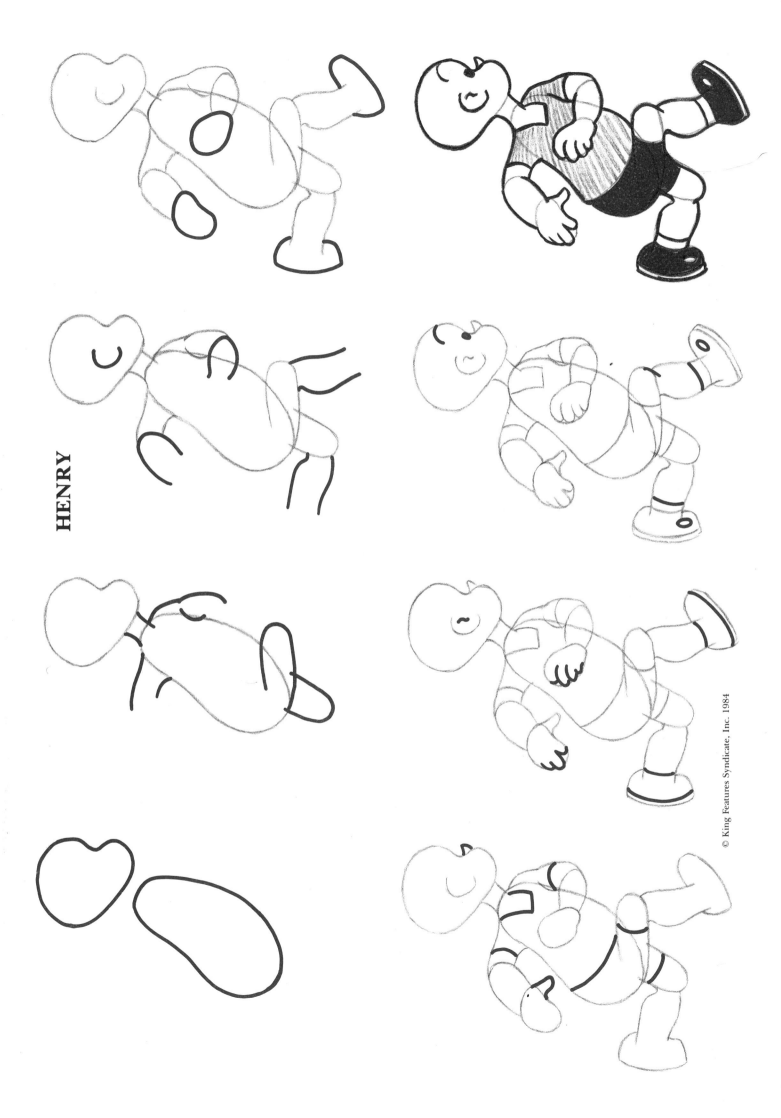

HENRY

LYLE THE LION

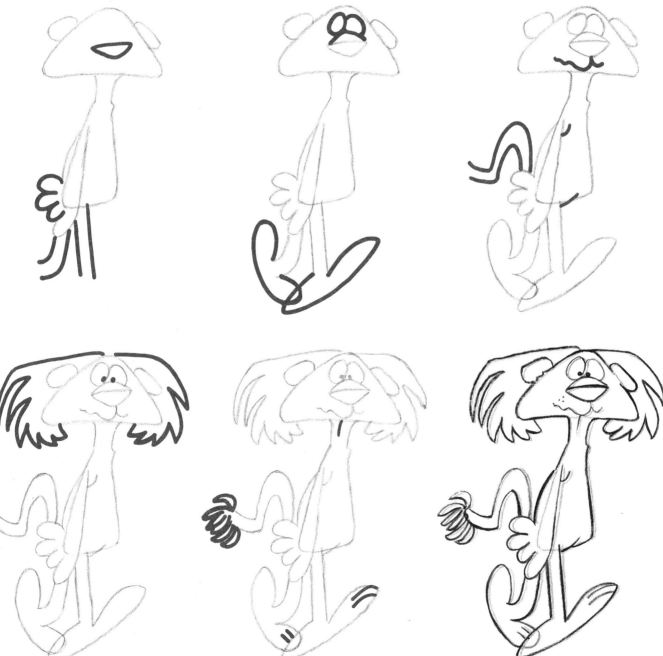

MOON MULLINS

HAPPY HOOLIGAN

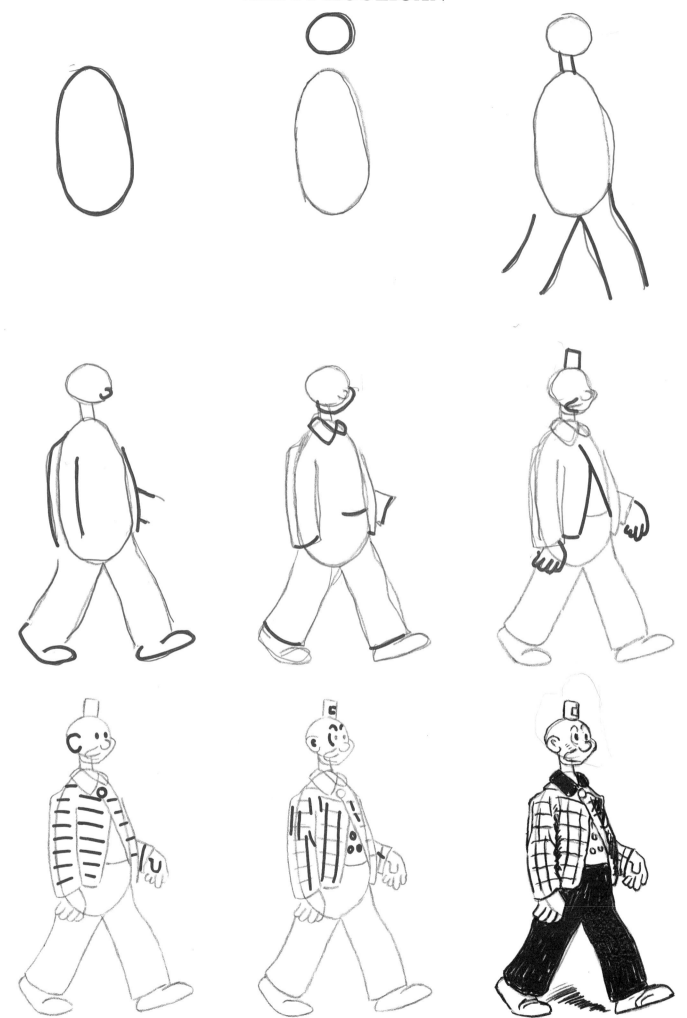

DRAW 50 FOR HOURS OF FUN!

Using Lee J. Ames's proven, step-by-step method of drawing instruction, you can easily learn to draw animals, monsters, airplanes, cars, sharks, buildings, dinosaurs, famous cartoons, and so much more! Millions of people have learned to draw by using the award-winning "Draw 50" technique. Now you can too!

COLLECT THE ENTIRE DRAW 50 SERIES!

The Draw 50 Series books are available from your local bookstore. You may also order direct (make a copy of this form to order). Titles are paperback, unless otherwise indicated.

ISBN	TITLE	PRICE	QTY	TOTAL
23629-8	Airplanes, Aircraft, and Spacecraft	$8.95/$11.95 Can	× _____	= _____
49145-X	Aliens	$8.95/$11.95 Can	× _____	= _____
19519-2	Animals	$8.95/$11.95 Can	× _____	= _____
24638-2	Athletes	$8.95/$11.95 Can	× _____	= _____
26767-3	Beasties and Yugglies and Turnover Uglies and Things That Go Bump in the Night	$8.95/$11.95 Can	× _____	= _____
47163-7	Birds	$8.95/$11.95 Can	× _____	= _____
47006-1	Birds (hardcover)	$13.95/$18.95 Can	× _____	= _____
23630-1	Boats, Ships, Trucks, and Trains	$8.95/$11.95 Can	× _____	= _____
41777-2	Buildings and Other Structures	$8.95/$11.95 Can	× _____	= _____
24639-0	Cars, Trucks, and Motorcycles	$8.95/$11.95 Can	× _____	= _____
24640-4	Cats	$8.95/$11.95 Can	× _____	= _____
42449-3	Creepy Crawlies	$8.95/$11.95 Can	× _____	= _____
19520-6	Dinosaurs and Other Prehistoric Animals	$8.95/$11.95 Can	× _____	= _____
23431-7	Dogs	$8.95/$11.95 Can	× _____	= _____
46985-3	Endangered Animals	$8.95/$11.95 Can	× _____	= _____
19521-4	Famous Cartoons	$8.95/$11.95 Can	× _____	= _____
23432-5	Famous Faces	$8.95/$11.95 Can	× _____	= _____
47150-5	Flowers, Trees, and Other Plants	$8.95/$11.95 Can	× _____	= _____
26770-3	Holiday Decorations	$8.95/$11.95 Can	× _____	= _____
17642-2	Horses	$8.95/$11.95 Can	× _____	= _____
17639-2	Monsters	$8.95/$11.95 Can	× _____	= _____
41194-4	People	$8.95/$11.95 Can	× _____	= _____
47162-9	People of the Bible	$8.95/$11.95 Can	× _____	= _____
47005-3	People of the Bible (hardcover)	$13.95/$19.95 Can	× _____	= _____
26768-1	Sharks, Whales, and Other Sea Creatures	$8.95/$11.95 Can	× _____	= _____
14154-8	Vehicles	$8.95/$11.95 Can	× _____	= _____
	Shipping and handling	**(add $2.50 per order)** × _____		= _____
		TOTAL		_____

Please send me the title(s) I have indicated above. I am enclosing $_____.

Send check or money order in U.S. funds only (no C.O.D.s or cash, please). Make check payable to Random House, Inc. Allow 4–6 weeks for delivery. Prices and availability subject to change without notice.

Name: _____

Address: _____ Apt. #_____

City: _____ State: _____ Zip: _____

Send completed coupon and payment to:

Random House, Inc.
Customer Service
400 Hahn Rd.
Westminster, MD 21157

BROADWAY